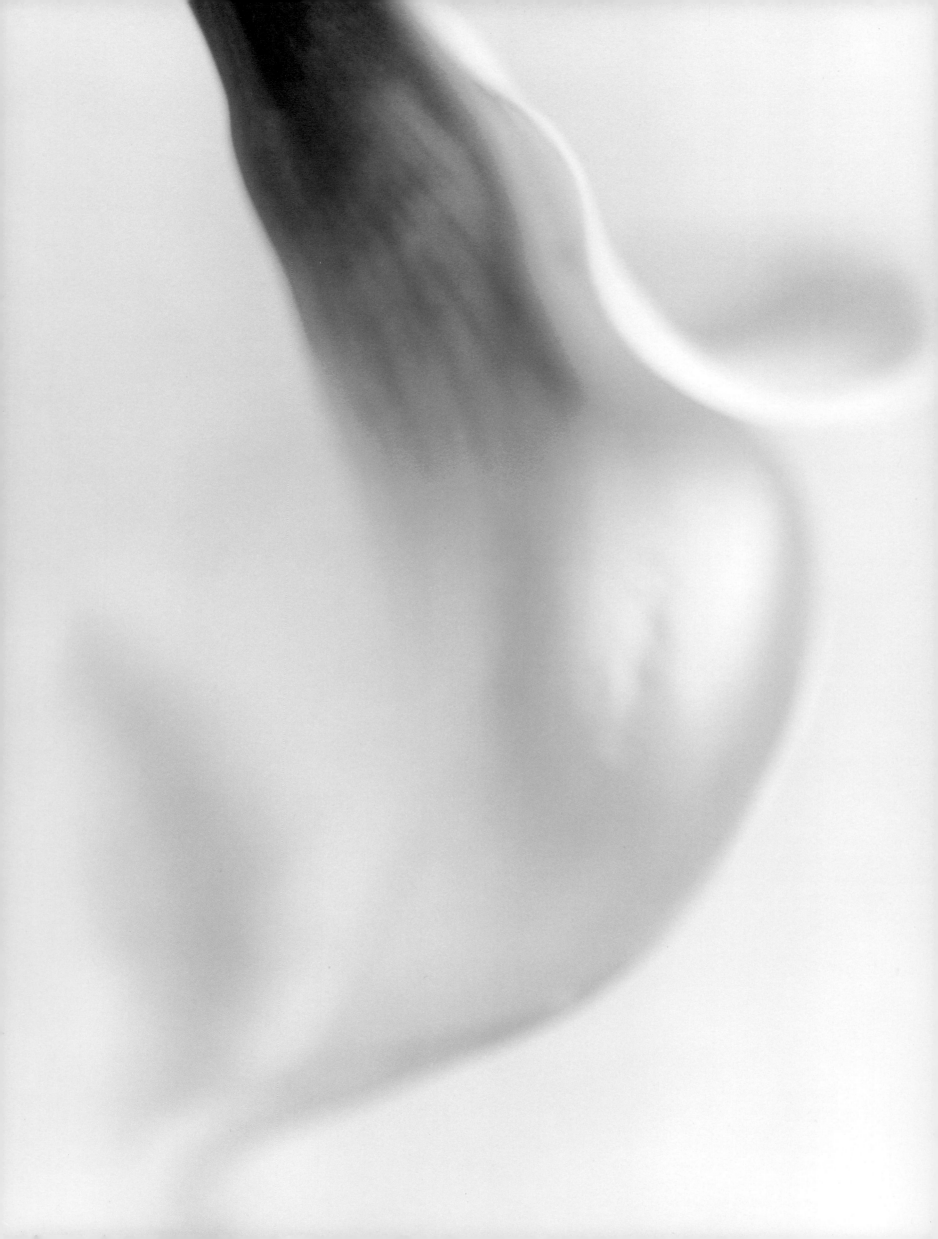

Sandi Fellman
Open Secret

Essays by
Diane Ackerman and Jerry Aline Flieger

EDITION STEMMLE
Zurich New York

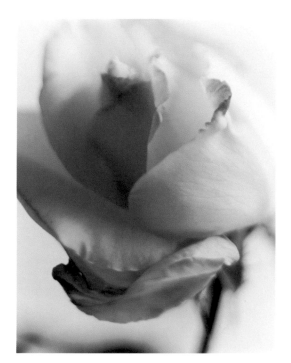

In your light I learn how to love
In your beauty, how to make poems.

You dance inside my chest,
where no one sees you,

but sometimes I do, and that
sight becomes this art.

Rumi

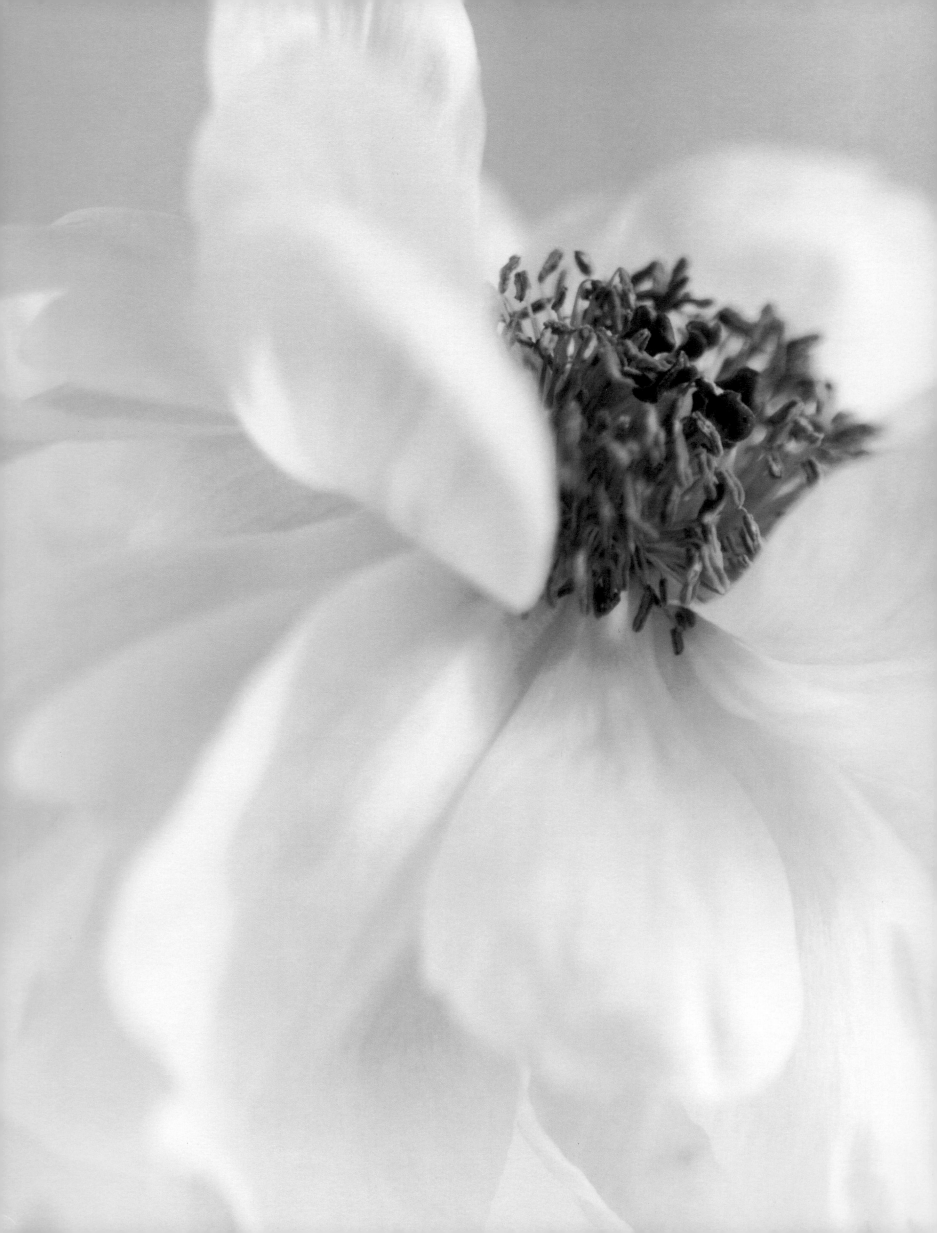

Open Secret
Diane Ackerman

Every flower is a garden, a small Eden for a nectar-craving butterfly, bee, or bird, not at all the petalled lushness we rub against our senses for enjoyment. Its goal is far more brazen. Voluptuousness is its job, deceit its genius. A virtuoso of bribery and disguise, it thrives on conning unsuspecting travellers. Flowers get all gooey and colorful to tantalize the likes of moth, ant, bat, bird, or mouse—in the hope that an agile stranger will move their pollen around. Since they're mainly stationary (except for the occasional bend or wobble), they need to persuade some other life form to perform sex for them. Their story is as honest and unsluttish as that, reminding us that nature doesn't judge or mean; it just is. We're the creatures who strive to be modest, moral or merciful. The rest of nature just struts, exposes itself, and oozes. Mind you, sex is probably more fun for us than for a flower—contrary to what some well-meaning folk may protest, I'm not convinced flowers experience a mood like fun—but it's also more torturous. An open secret among humans is that, at least once in one's life, one wishes sex were as straight forward for us as it is for flowers.

Although flowers convey volumes of information to bugs and birds and one another, humans have always employed them as vivid messengers of love's many moods, and the Victorians went so far as to treat them as servants, making sure they were properly dressed, spoke correctly,

and had all the right references. Sending your sweetheart peach blossoms meant I am your captive. Sending him aloe meant grief. A bright jonquil meant Return my affection! Bluebells were for Constancy, but buttercups shouted Ingratitude. Because pine needles spelled Pity, one urgently noted in which direction they were tied. If the flowers arrived with a ribbon tied to the left, they spoke of the sender; tied to the right, of the recipient. A petunia meant Never despair, while yarrow threatened all-out War. One might compose a bouquet of peonies (Feeling bashful), zinnias (Thinking of you), burgundy roses (Unconscious beauty), and snowdrops (Hope), in what amounted to a visual haiku. Lovers have always looked for ways to side-step the embarrassment of revealing their gaping, ravenous, unadorned need. Sending a flower-code was less risky than declaring one's feelings gaze by blush, behind trembling eyelashes. The feeling need not be a surprise to the beloved, of course, merely heretofore unstated. How like a flower is a romance deepending, unfolding in exquisite slowness to a rapture of scent, form, and color. When fully open, a flower offers no other possibility. It is the full expression of its destiny, the culmination of routine biology and individual traits. When fully revealed, love seems always to have been a fateful crossroads where two quirky people arrive hauling all sorts of baggage.

Flowers are like poems. Consult them for delight, and they'll delight you. Look to them for deeper truths, and you'll find much to mull over. Some of their music falls on deaf ears, some of their billboards go unseen. For example, I would need the eyes of a bee to spot the target-shaped designs on many flowers. Providing perfect approach guides and landing pads, they invite a militia of rowdy visitors to come and dine, in the process smearing them with pollen to carry blindly to the next port of call. They do not know their offspring. But, then, they do not know. They simply are. Given that, how lucky we have senses that relish colors and

savor fragrances. We don't need to be attracted to flowers. That they delight us is a happy accident, only a lavish form of sensory noise, a casual byproduct of evolution. All the more reason to peer into their nooks and crannies, convolutions and folds, hanging-out tongues and plump pouches. If they "hide their light under a bushel," as the old adage goes, then they are both light and bushel, the beginning and the end, the blooming dance of life. They are megaphones of scent, broadcasting their whereabouts in molecular slogans. We color them with our memories. They stain us with their charm. We gather them like bon mots on a sleepy morning, and arrange them face to face in vases, as if they could speak among themselves. A guest in the summer house of the soul is a flower.

The beautiful photographs by Sandi Fellman that follow pose flowers nakedly in darkness and light. They serve the viewer's eye, but elude the touch, which is sometimes the way with beautiful things. But the silky pages of a book may be stroked like petals. Floral shapes, glimpsed in half-light, can illuminate paths through a garden of memories. And, when one applies the ear-trumpet of imagination, flowers can be heard whispering some of life's oldest secrets.

Plates

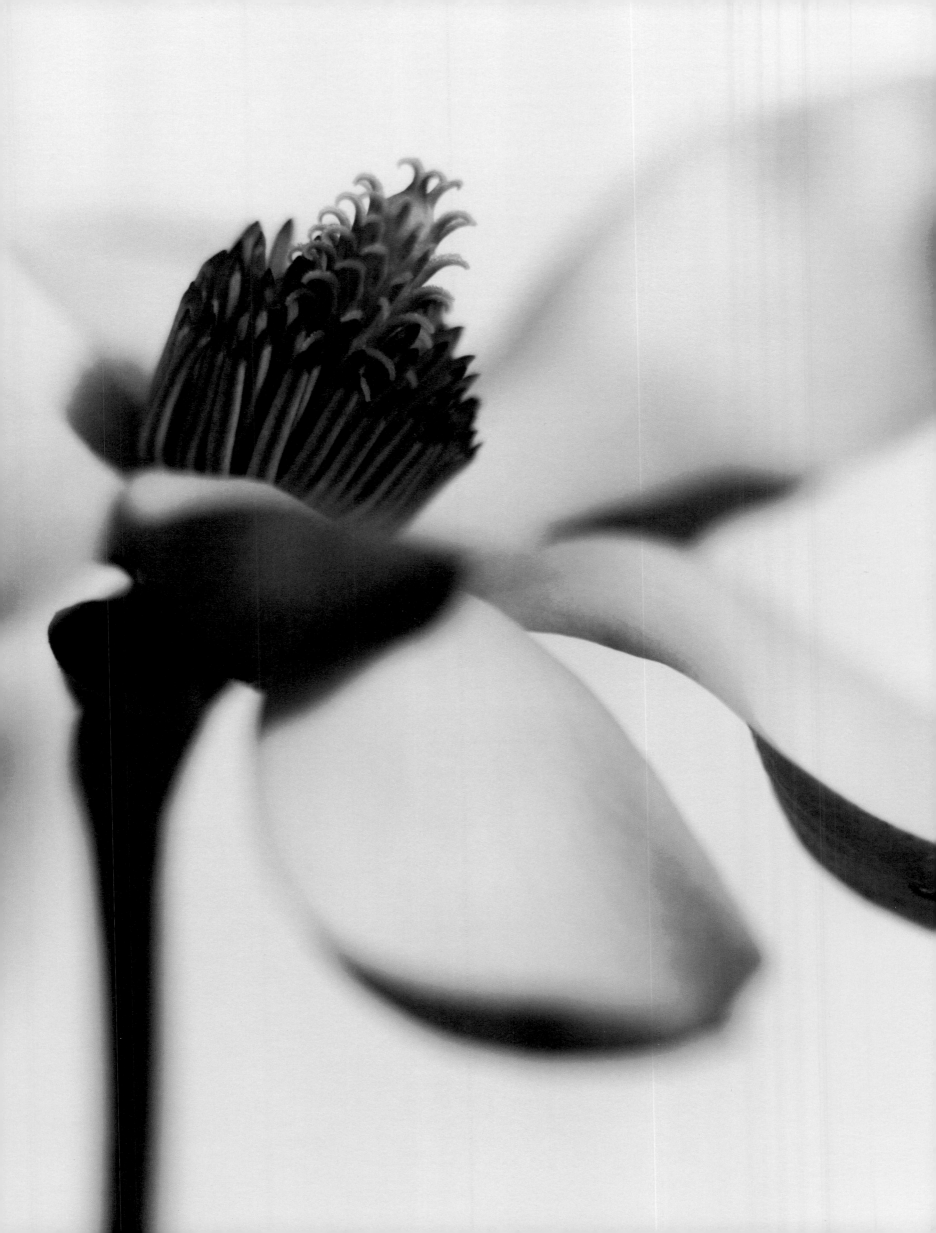

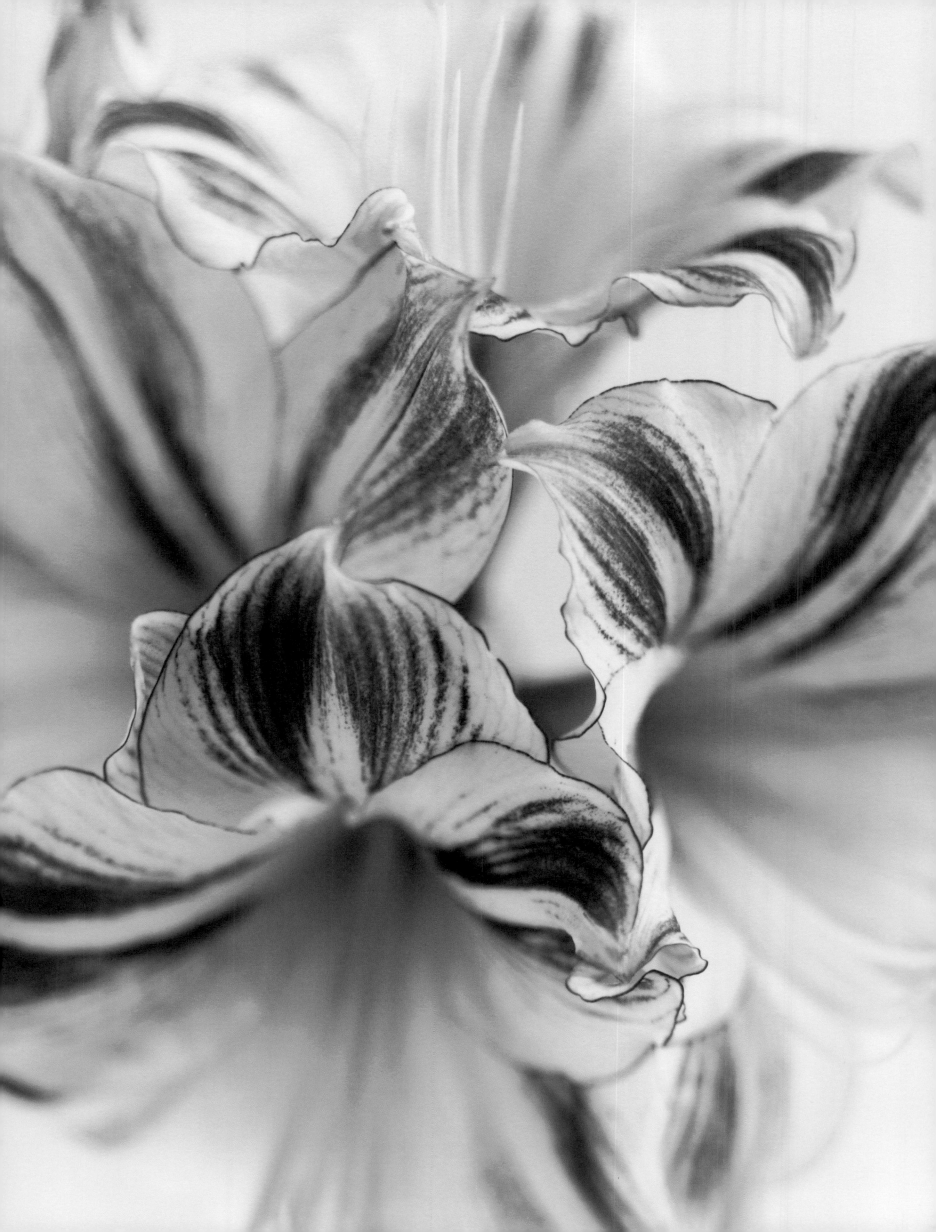

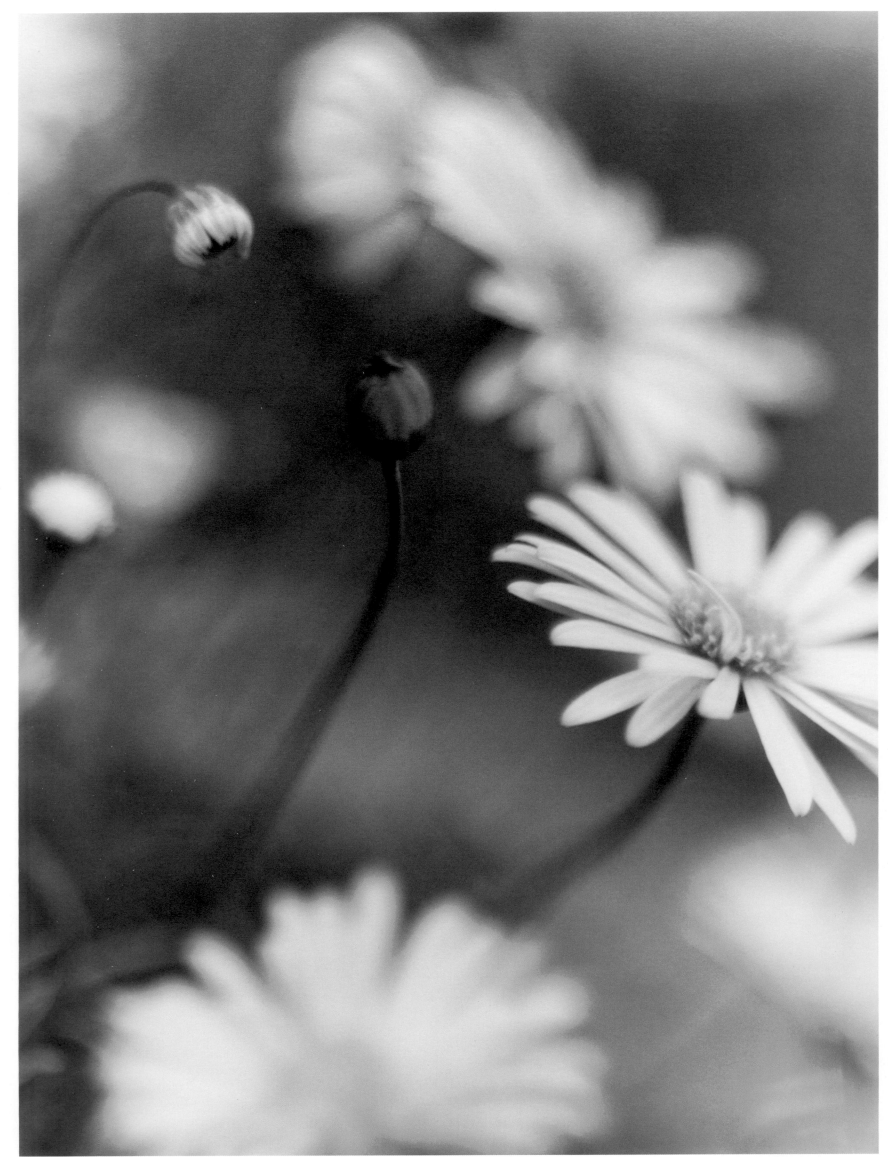

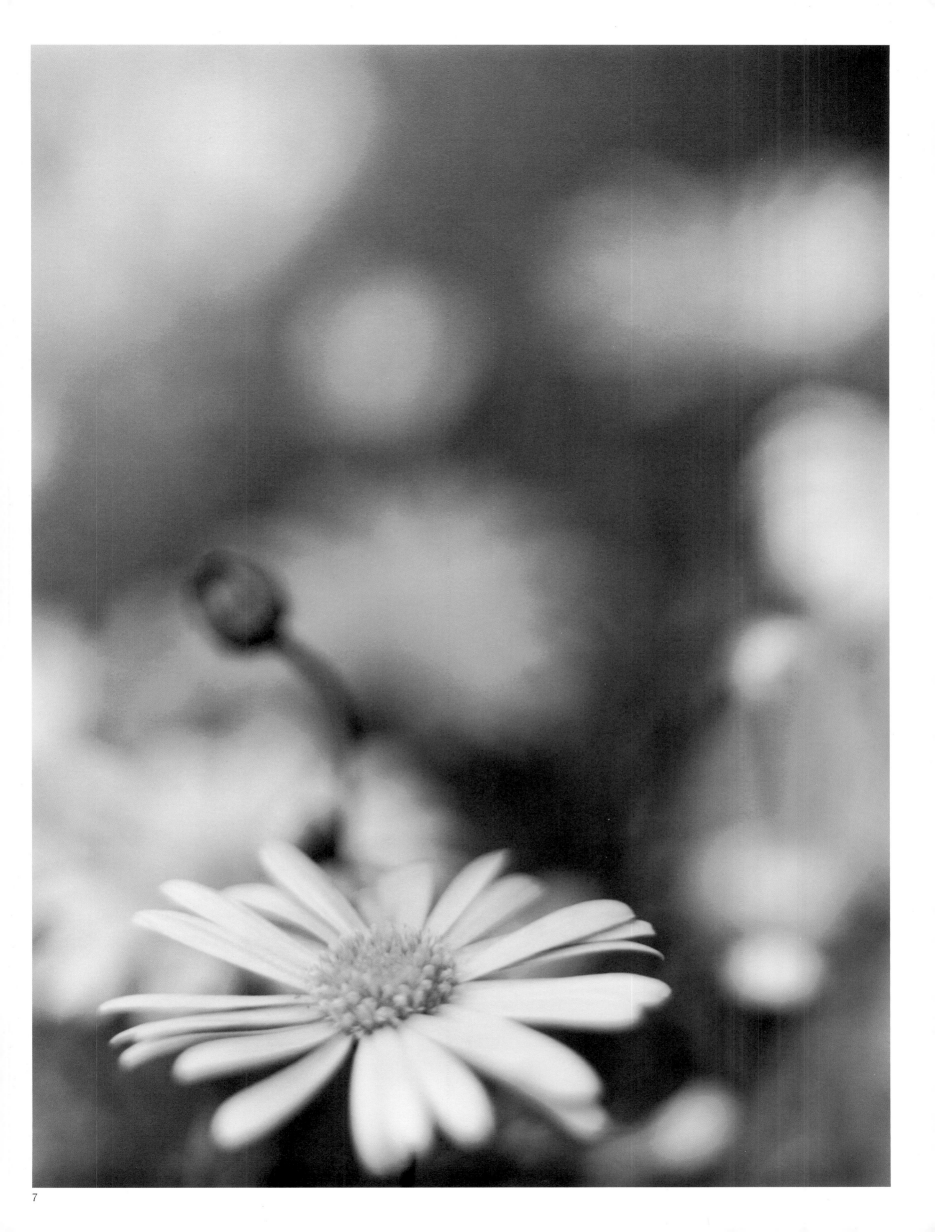

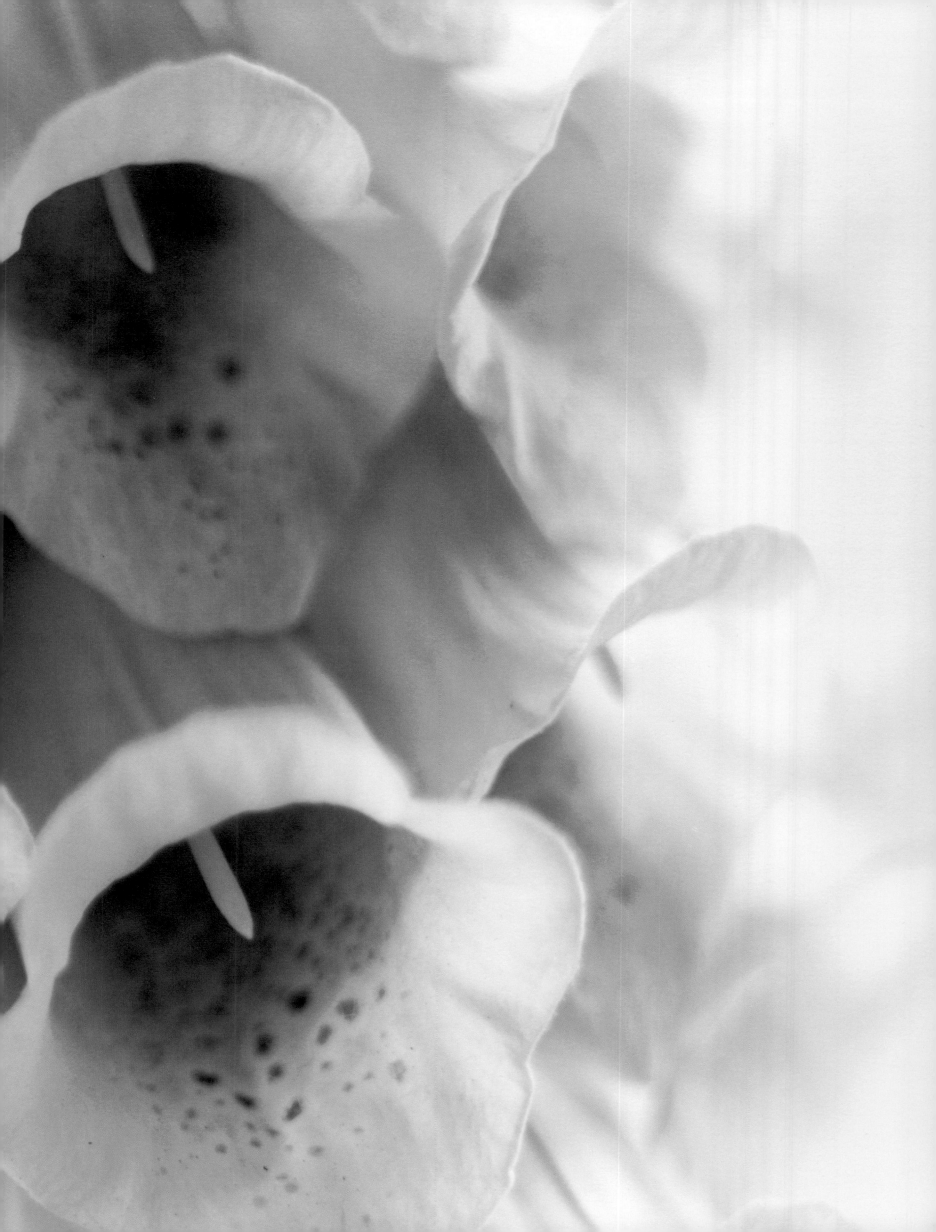

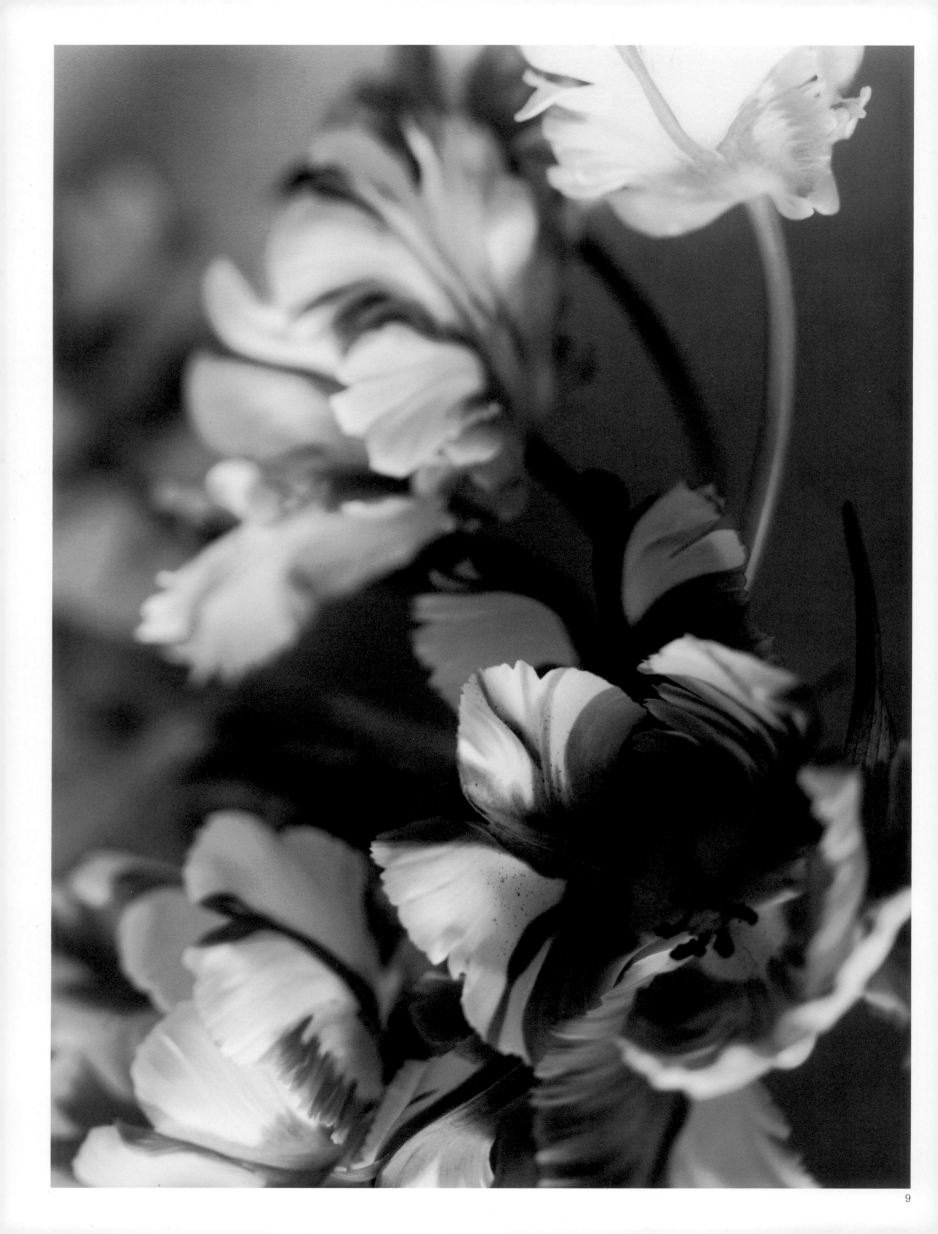

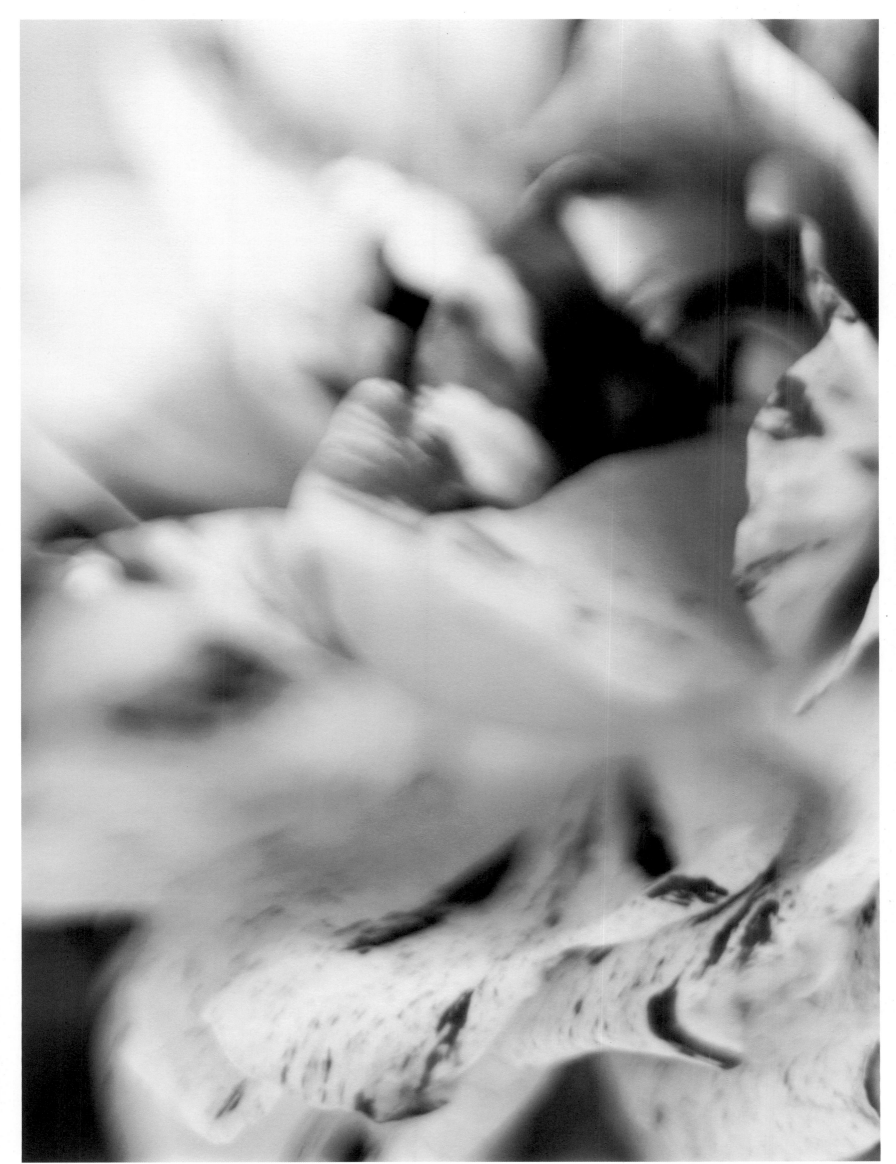

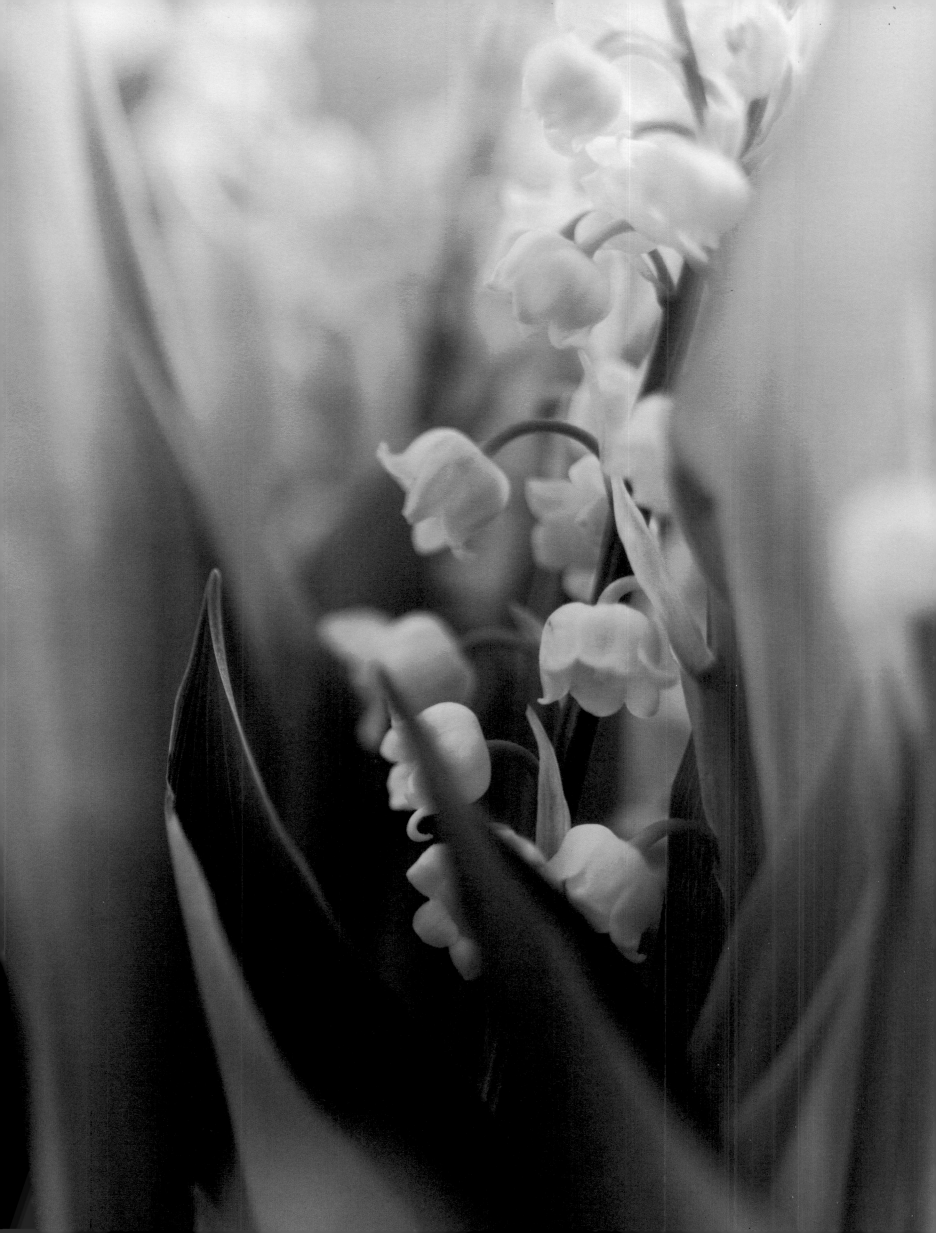

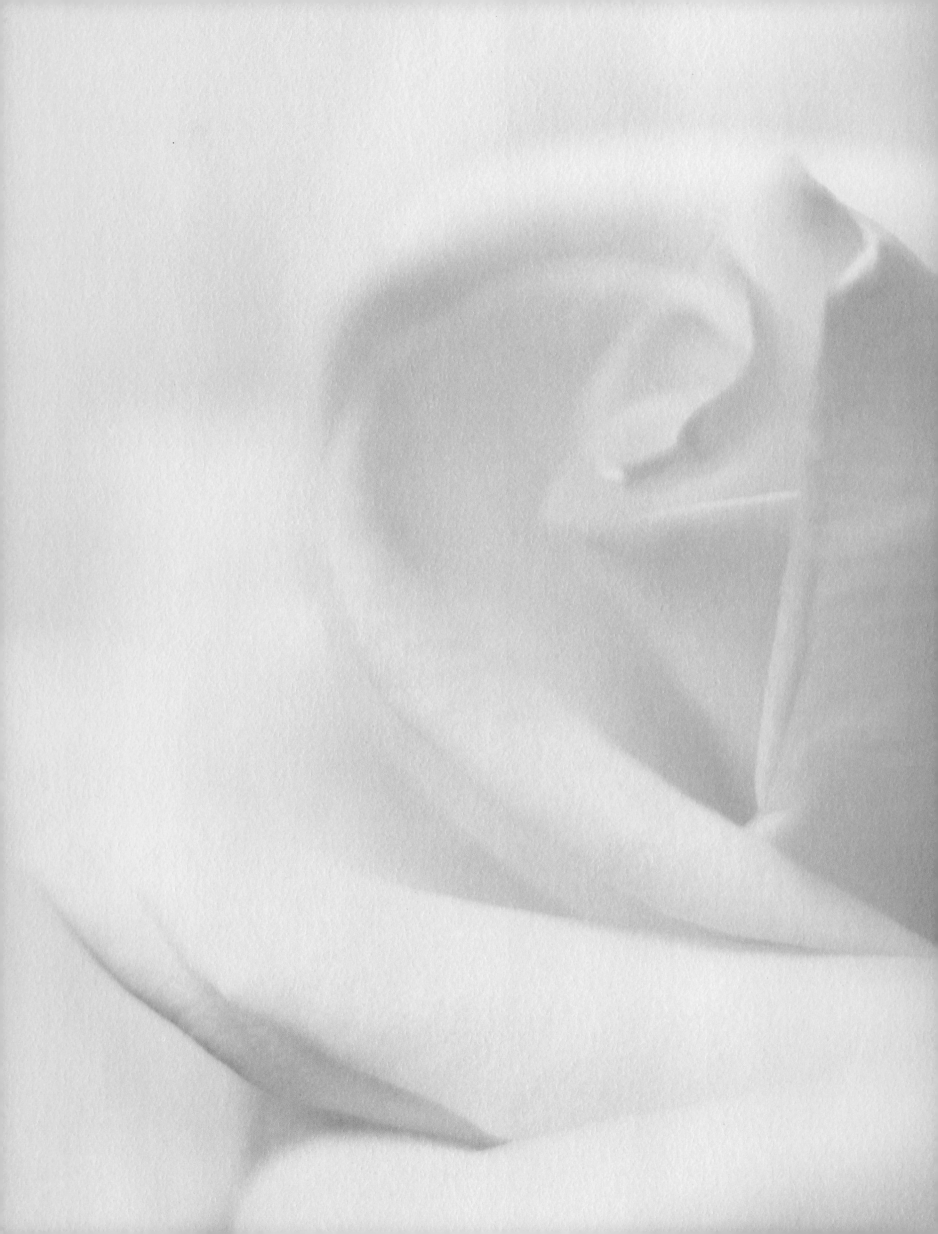

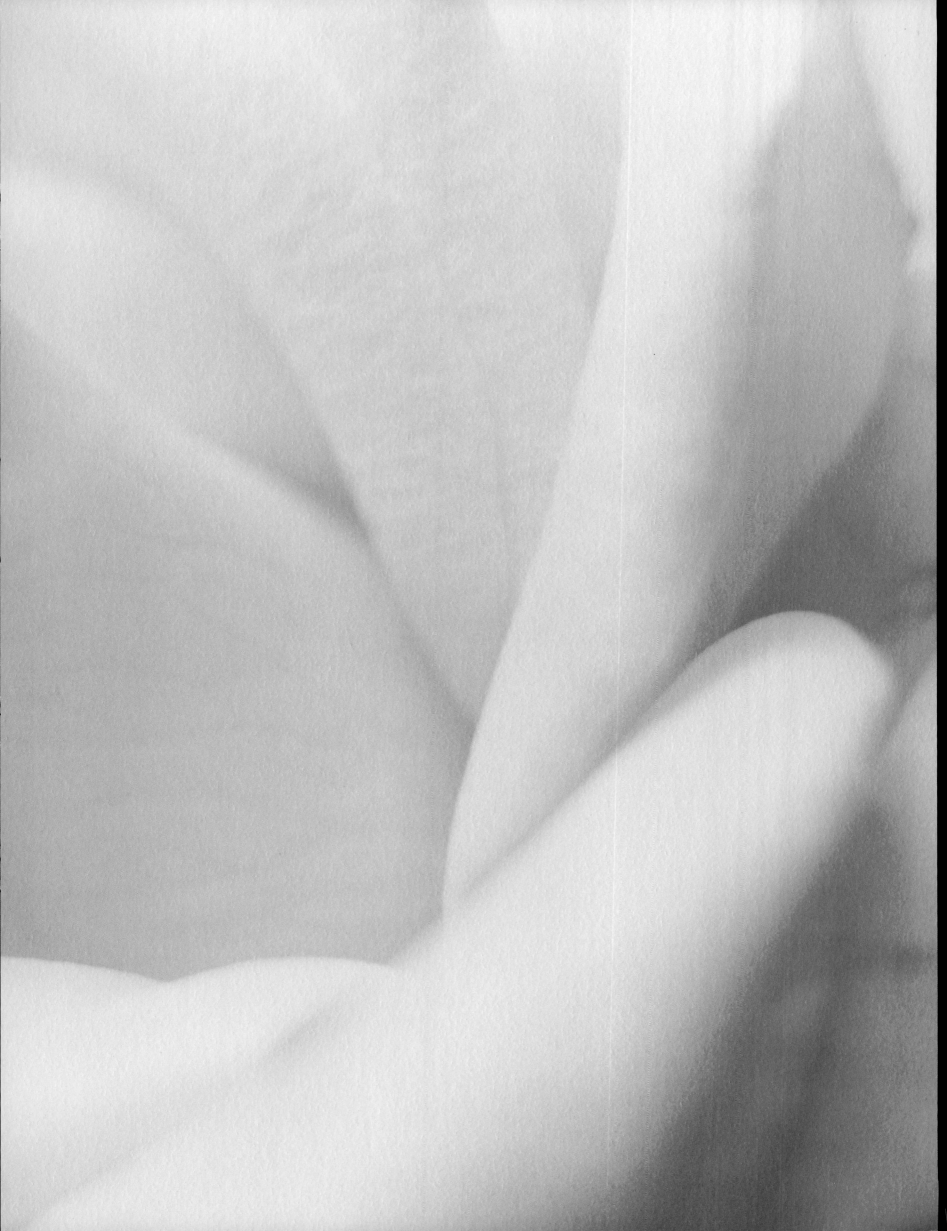

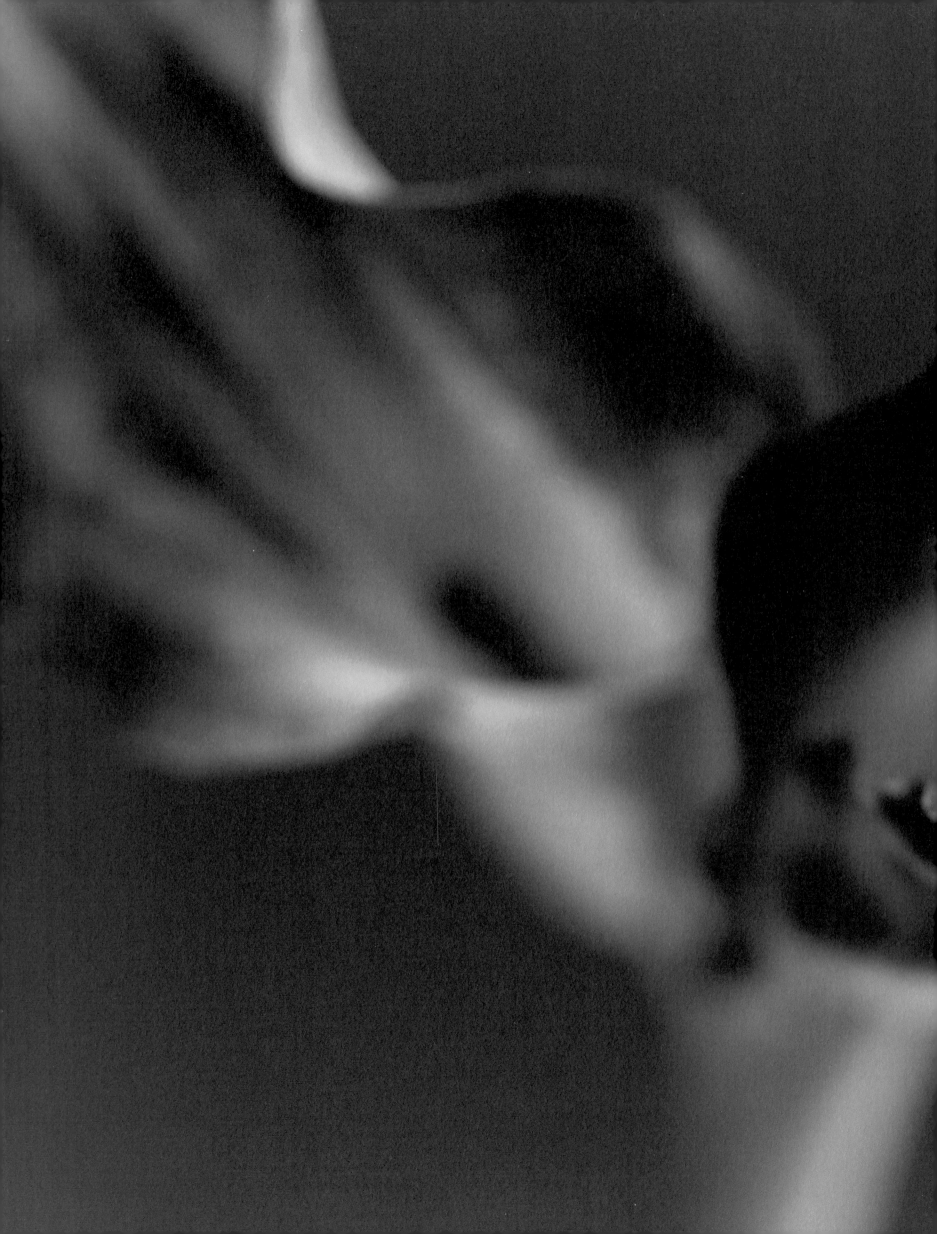

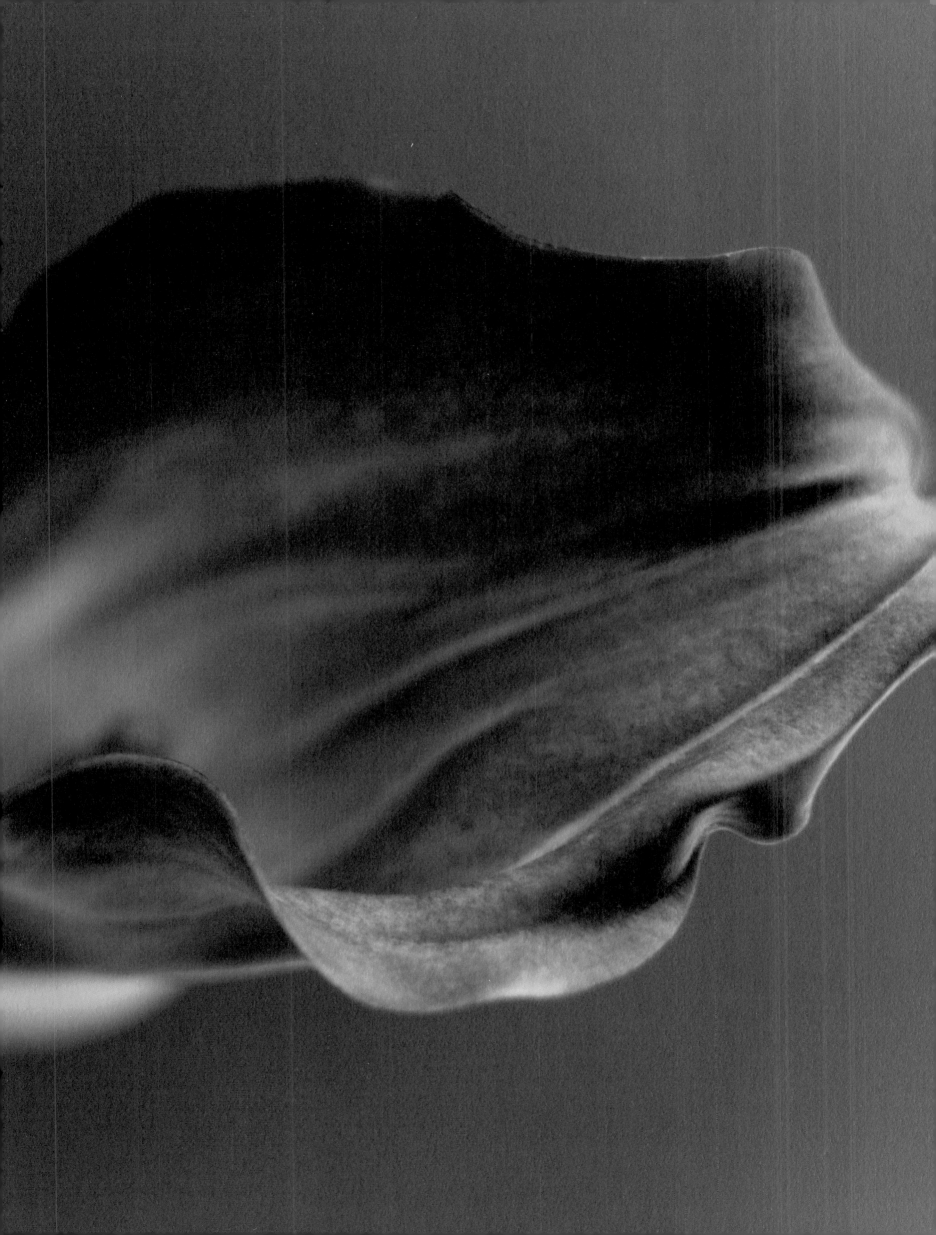

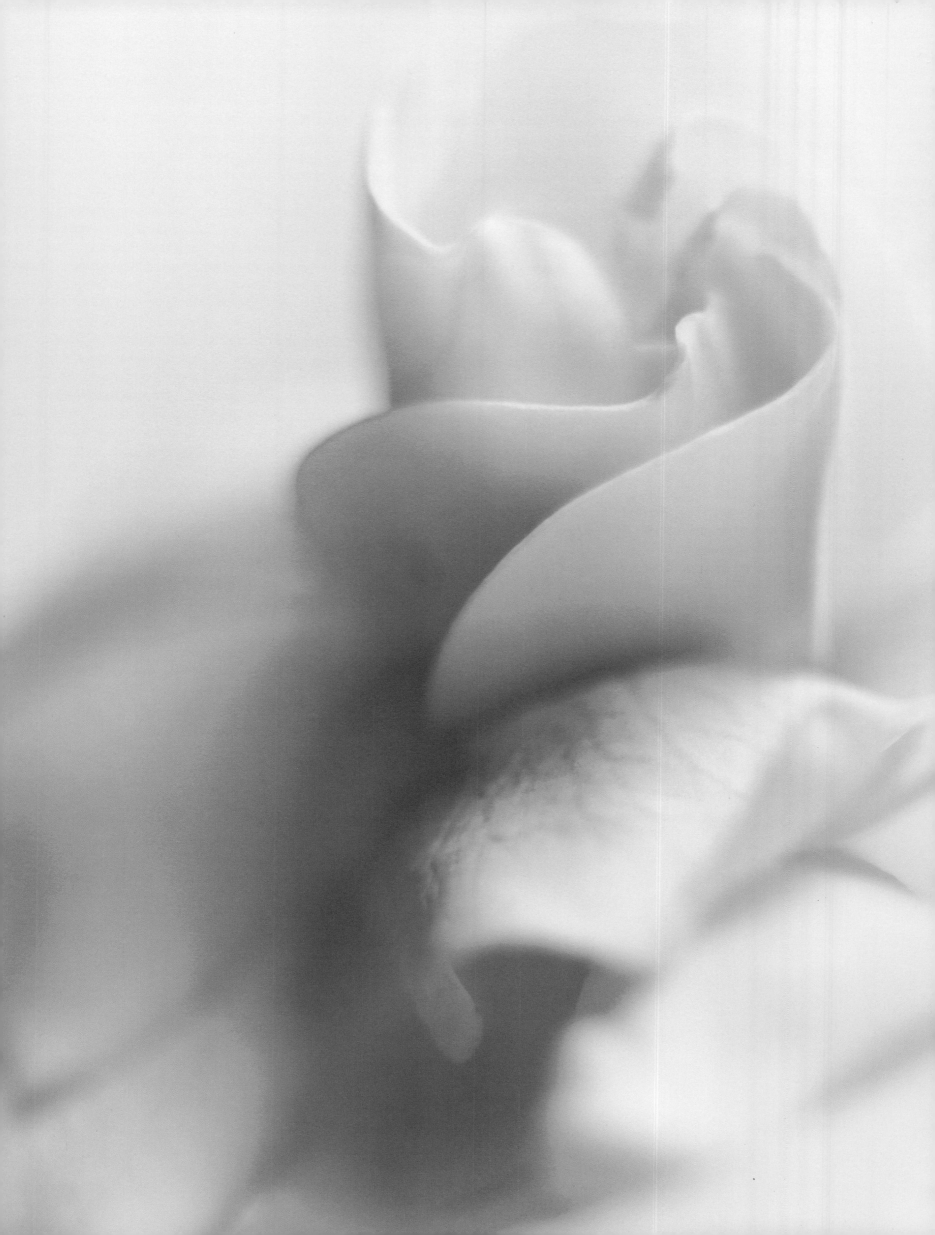

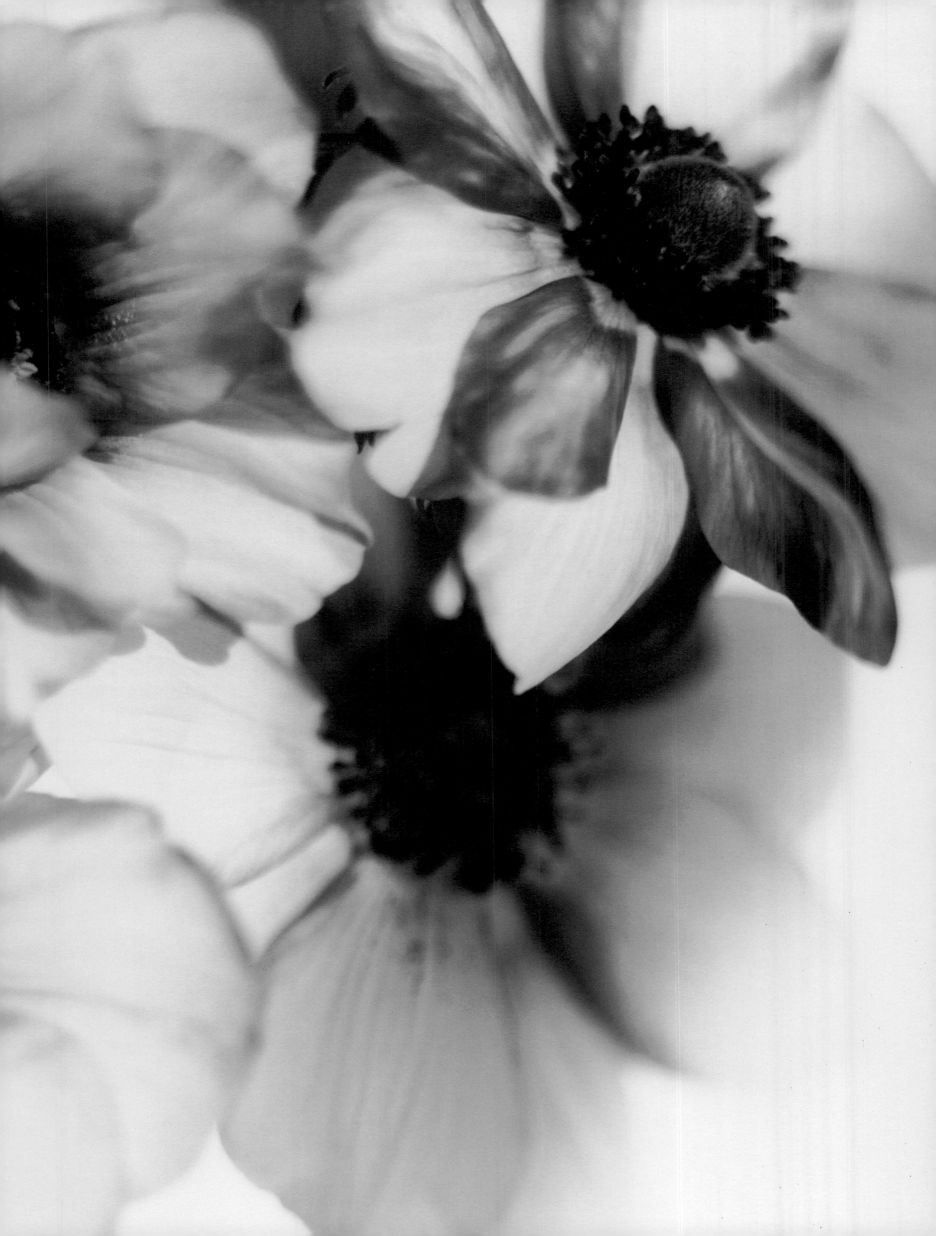

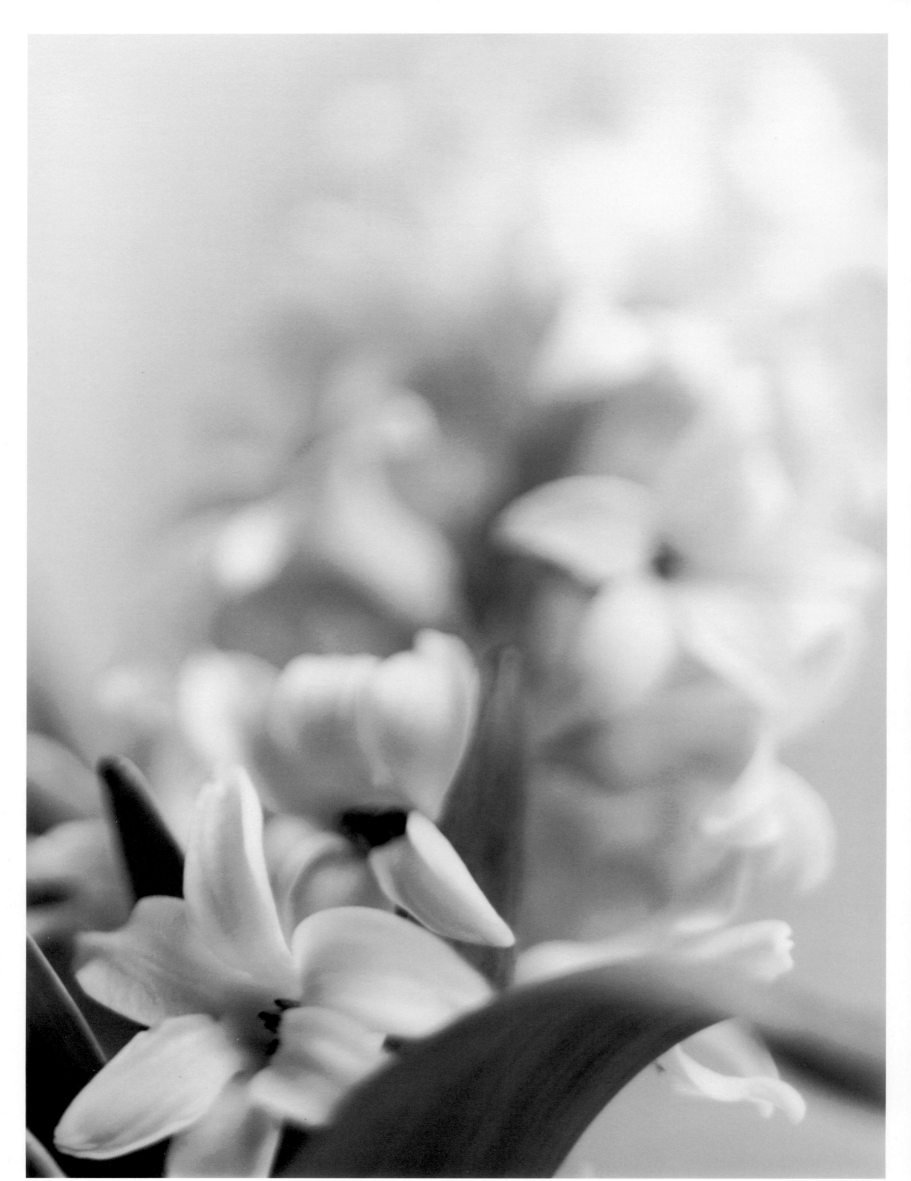

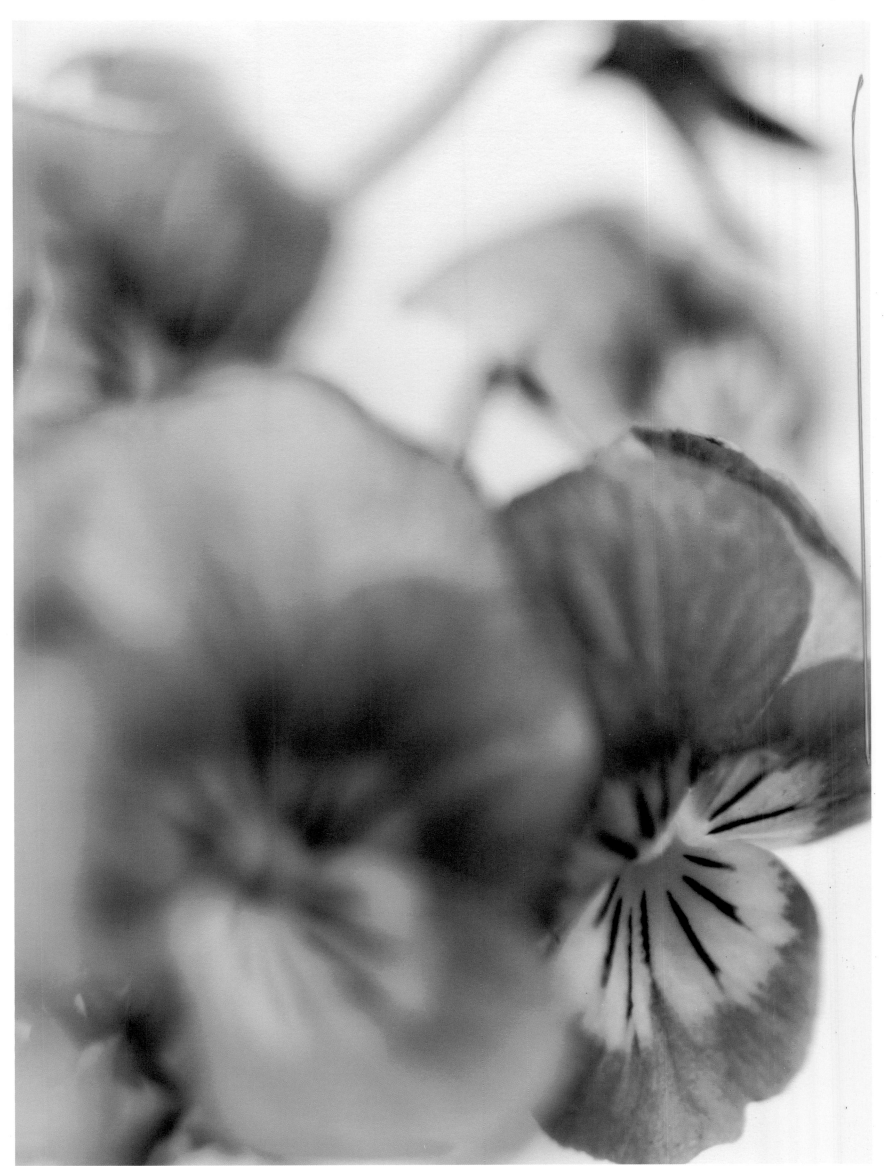

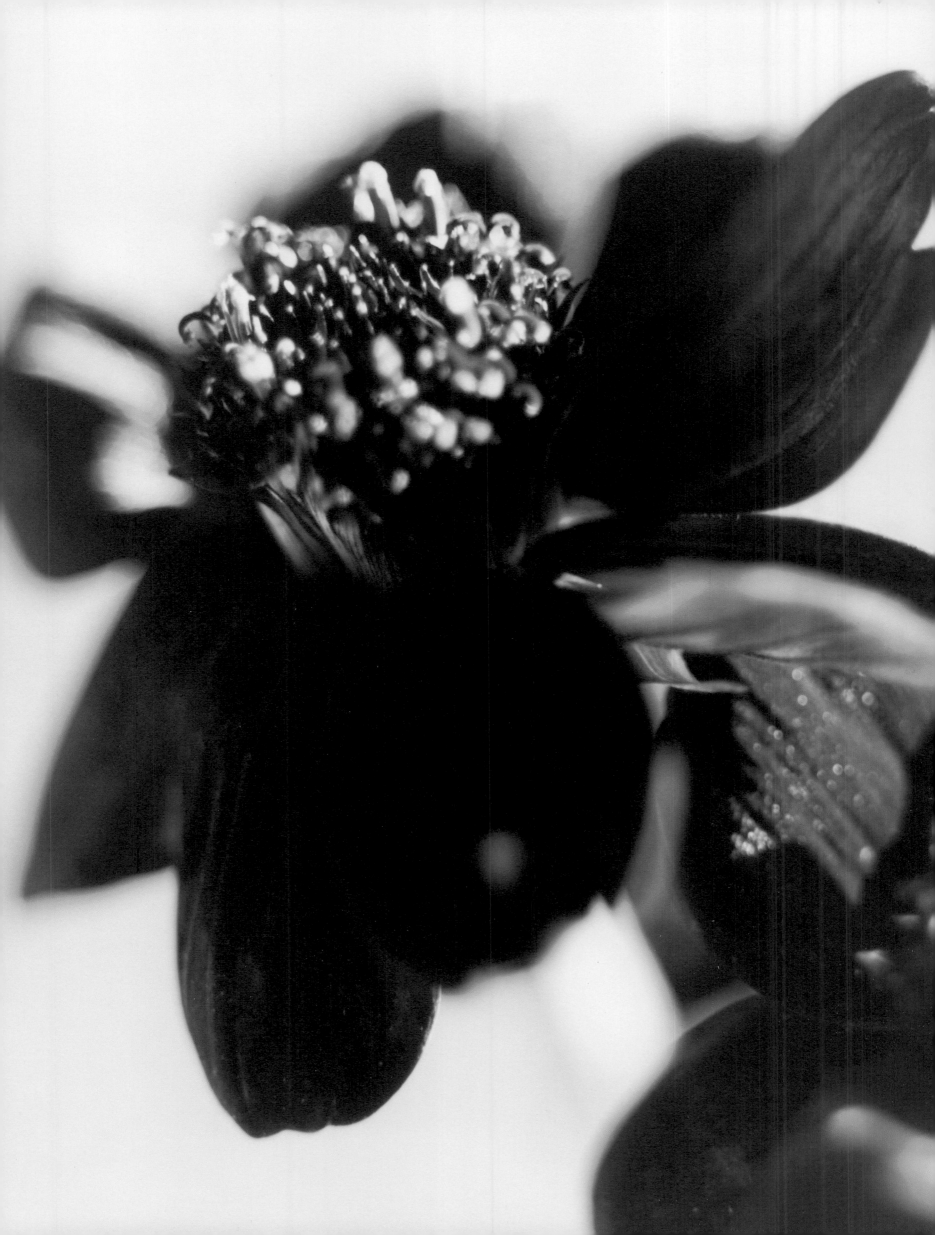

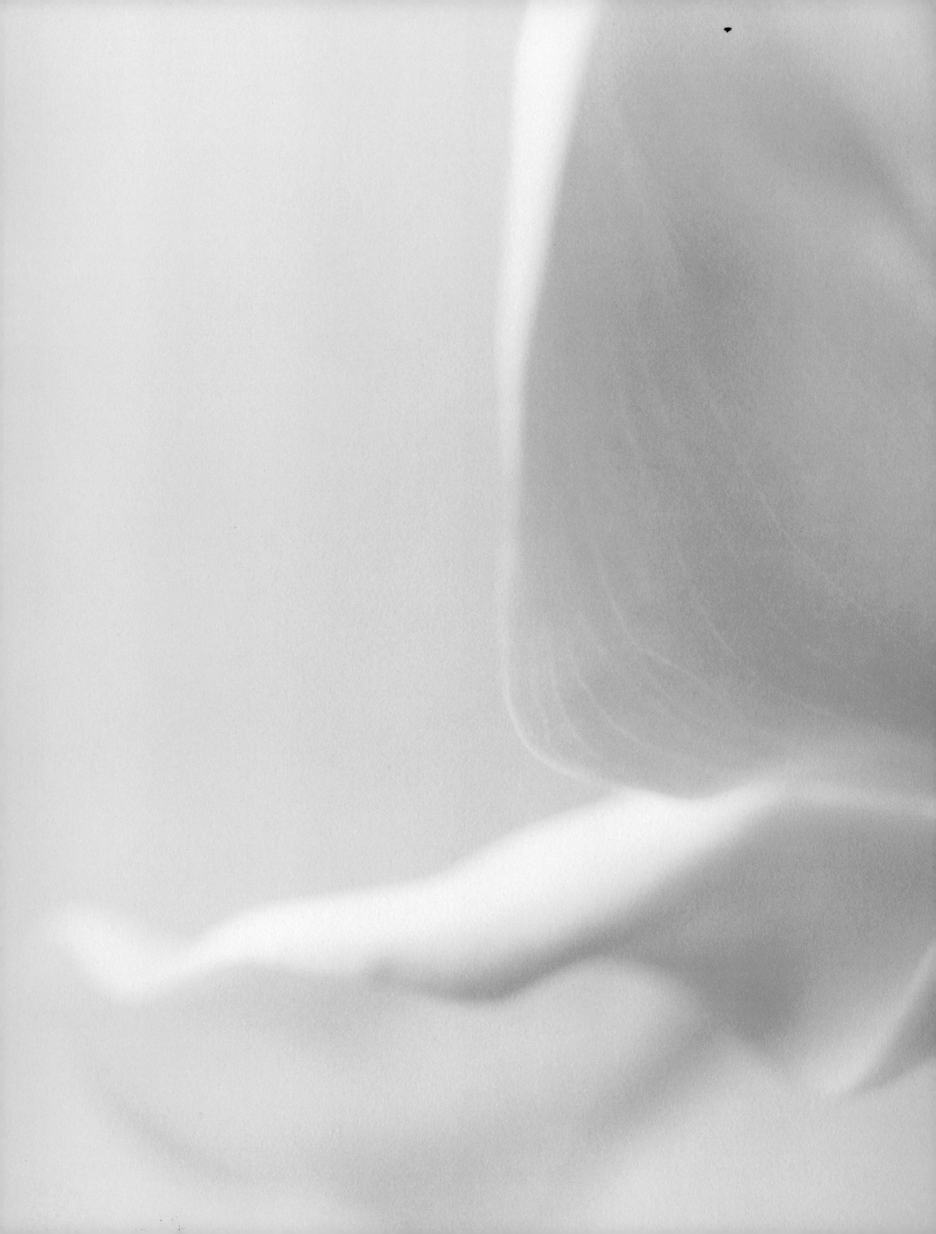

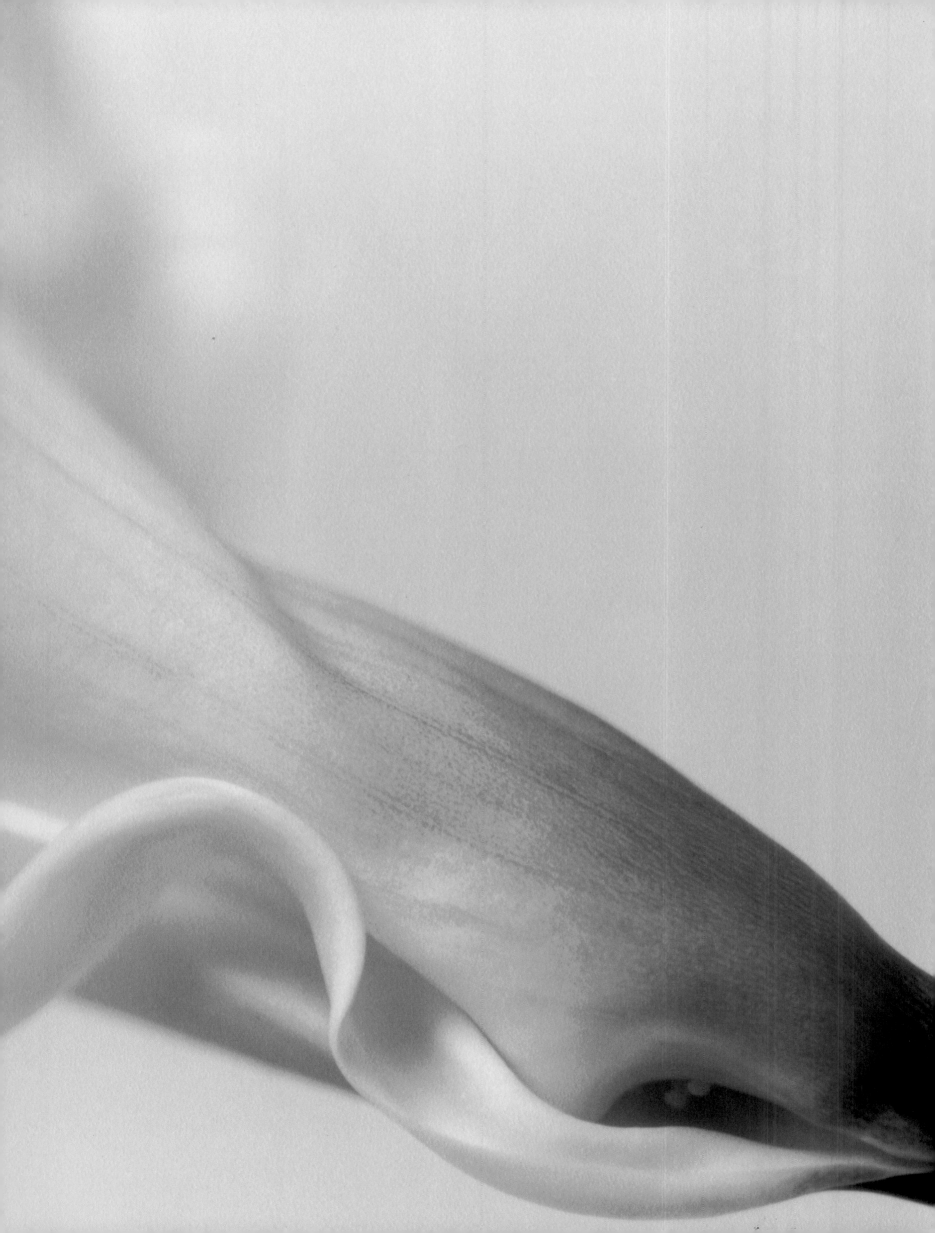

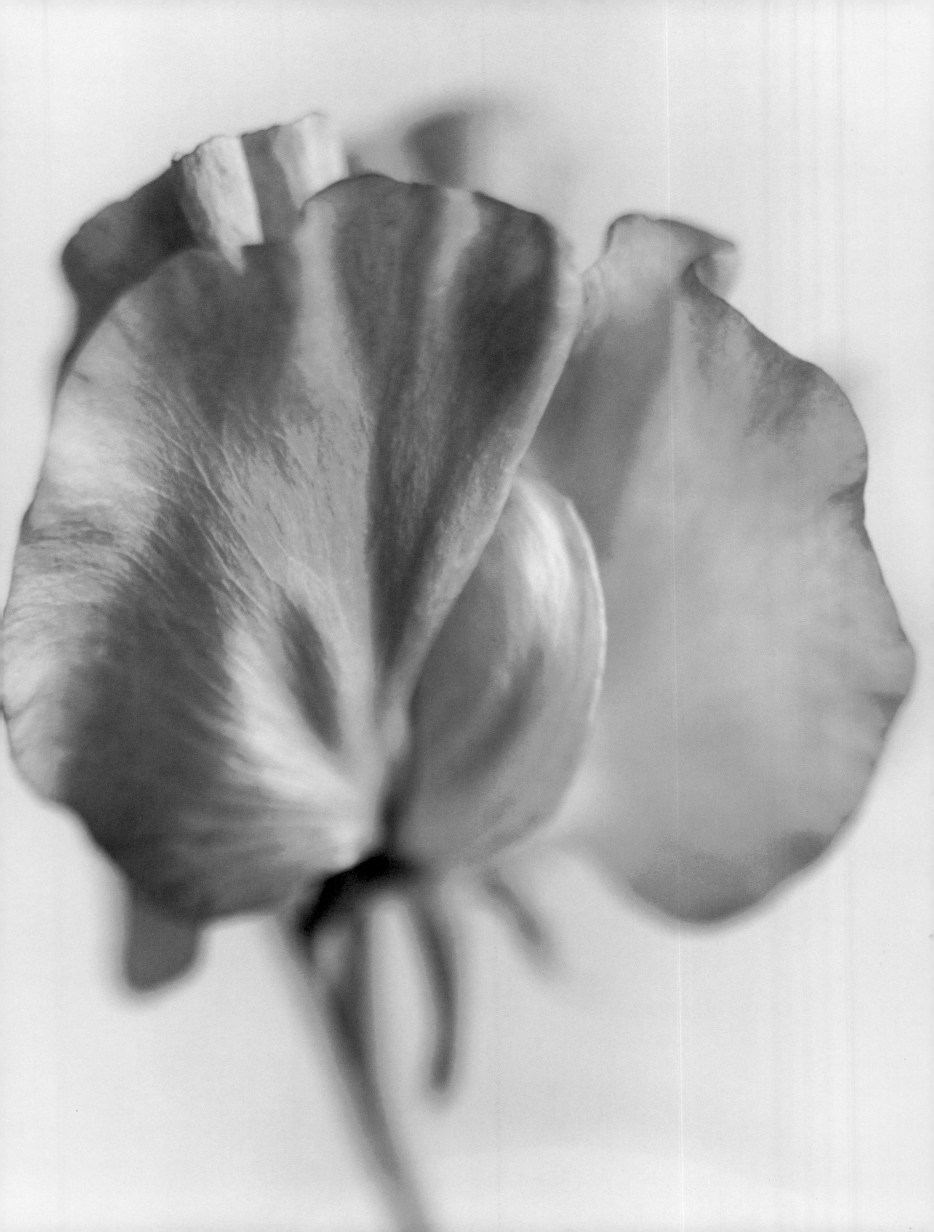

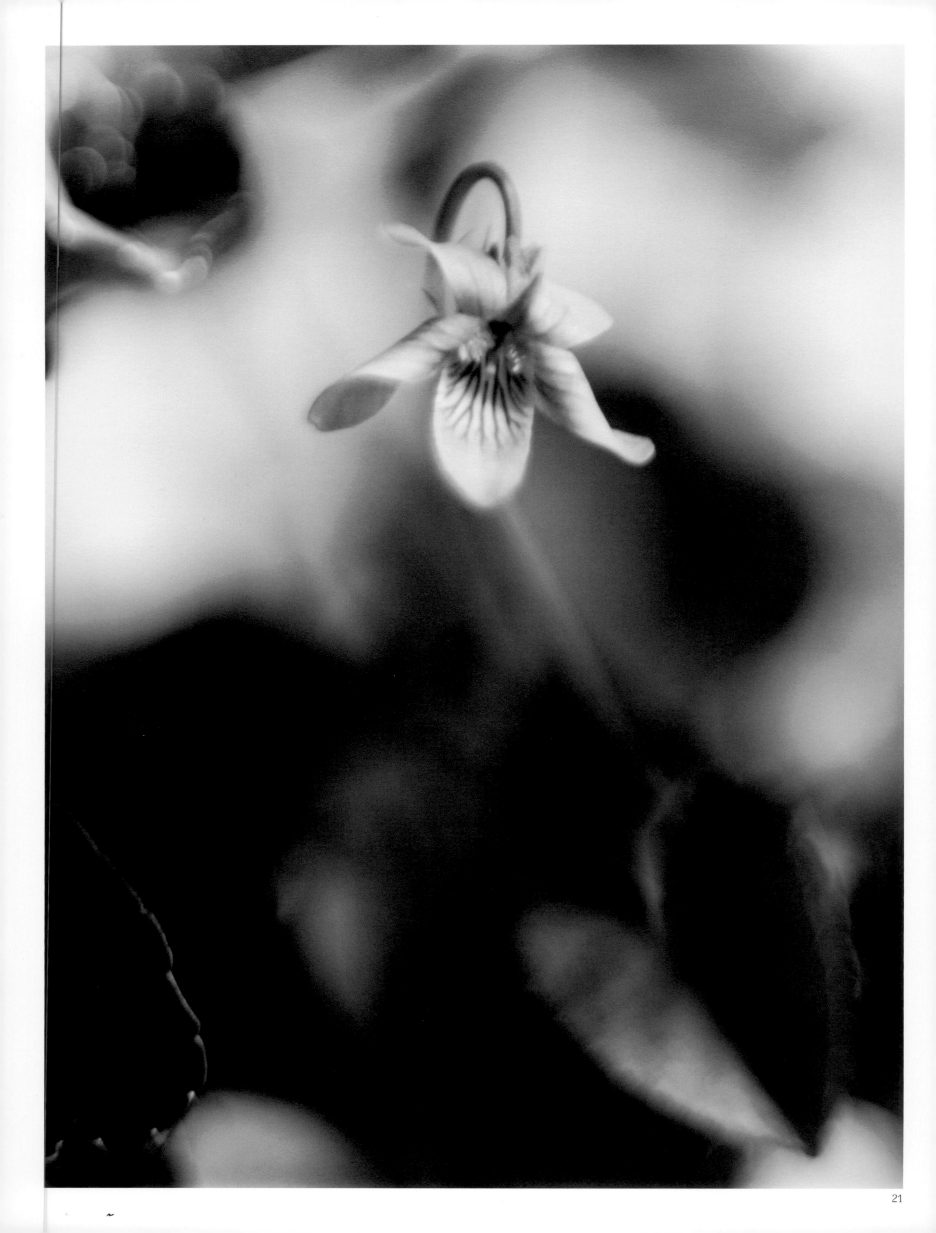

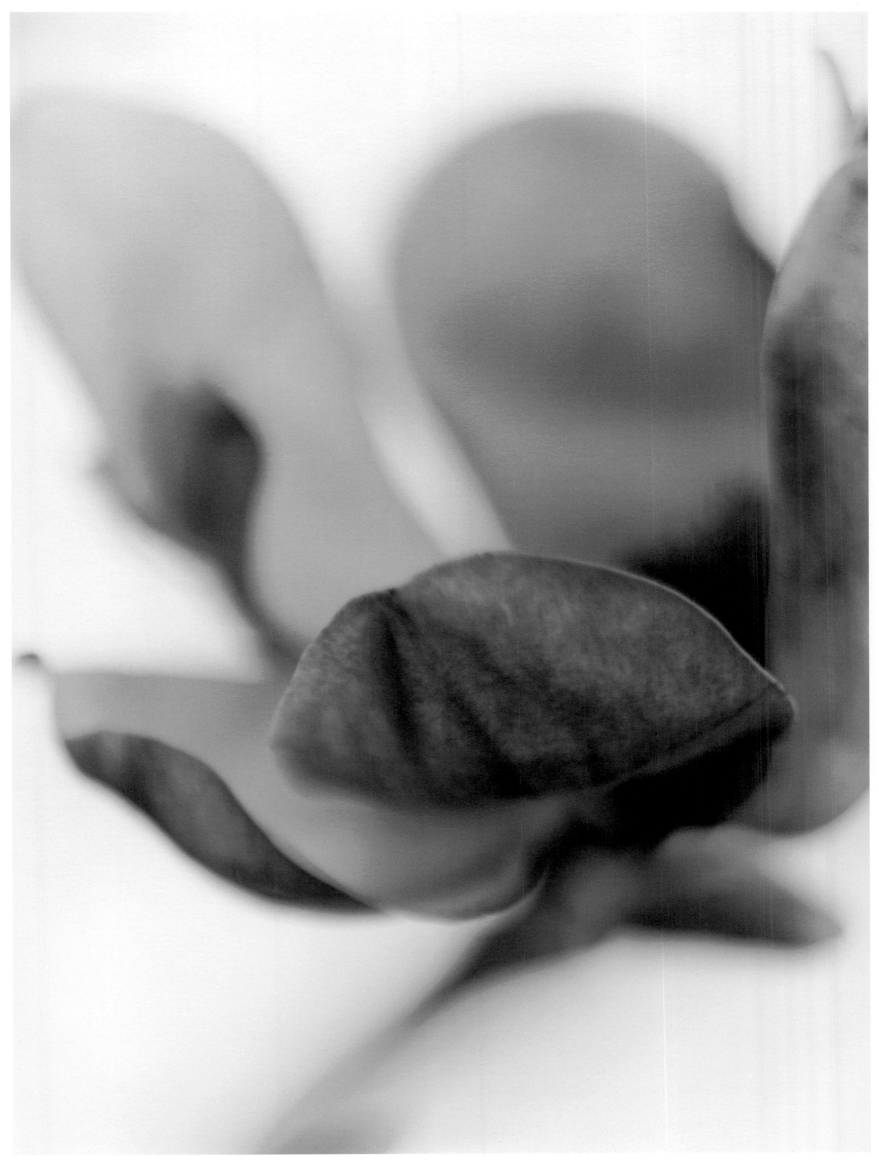

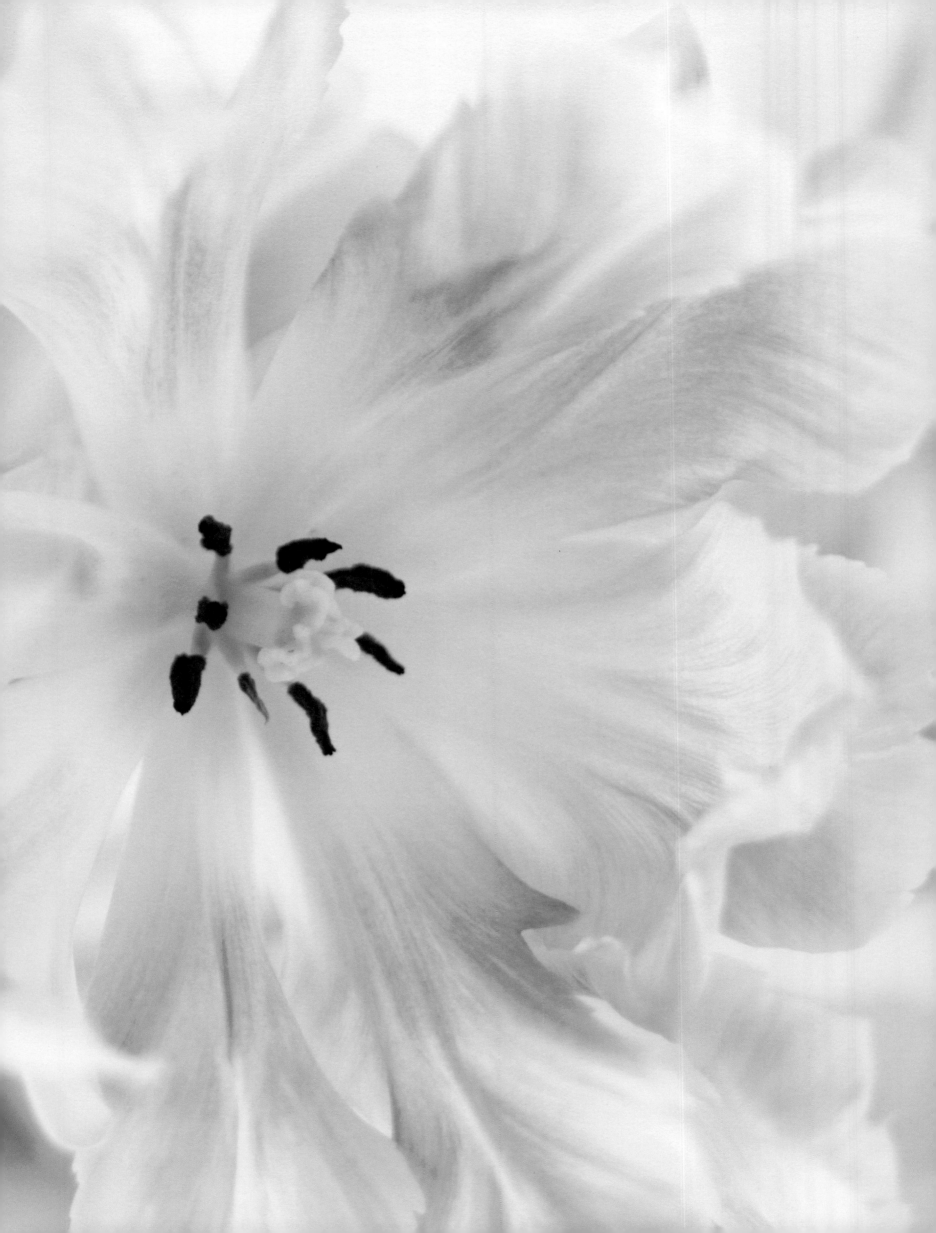

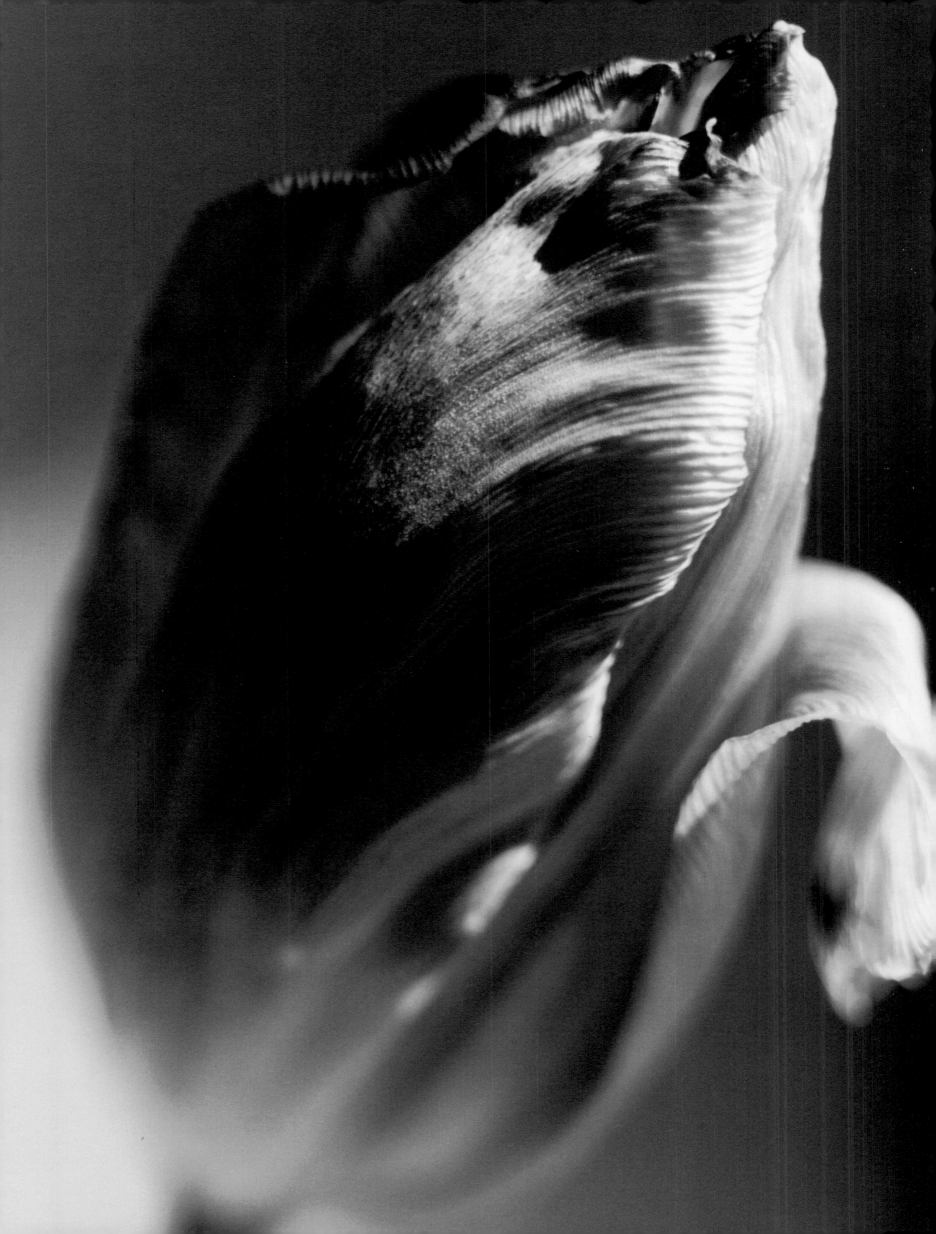

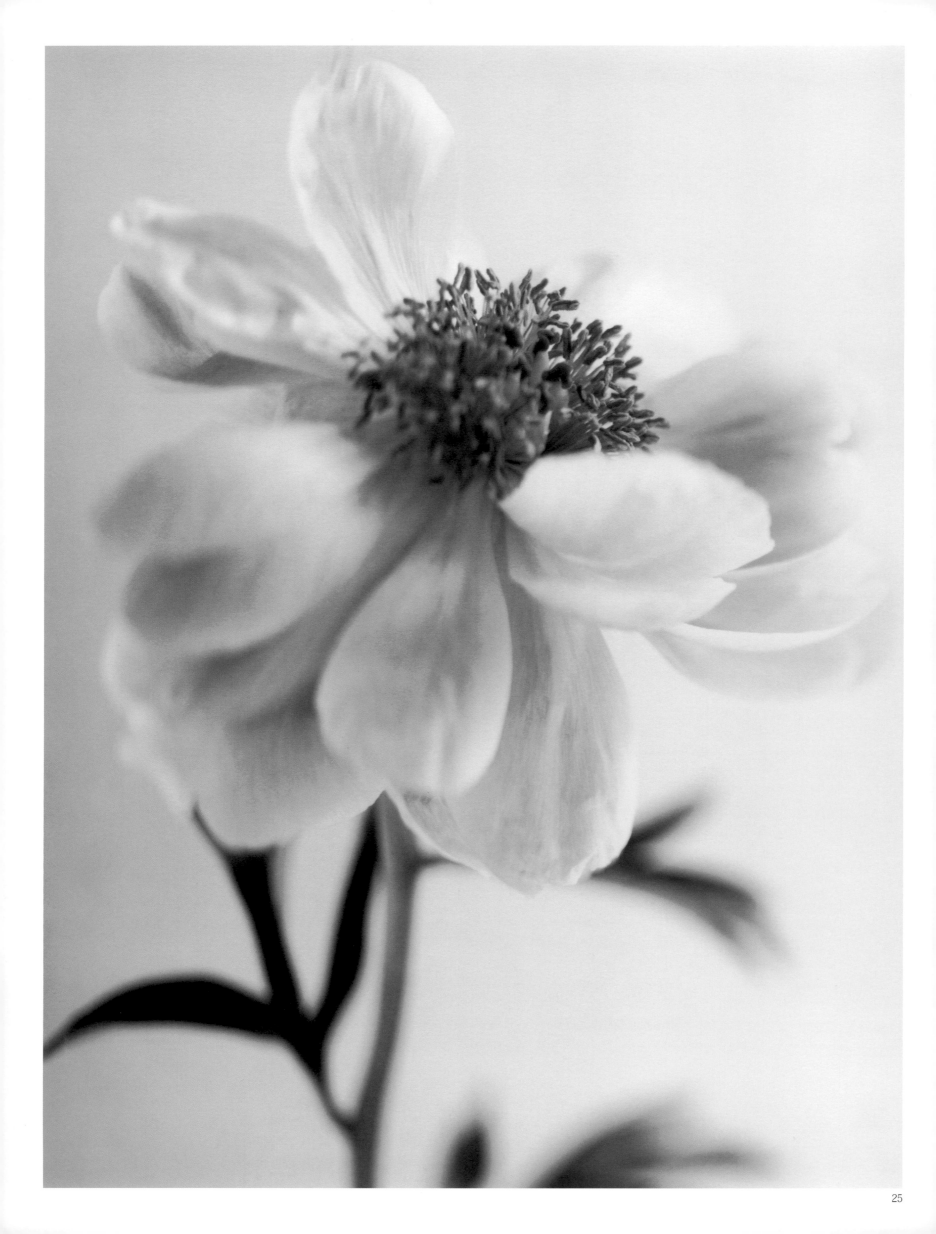

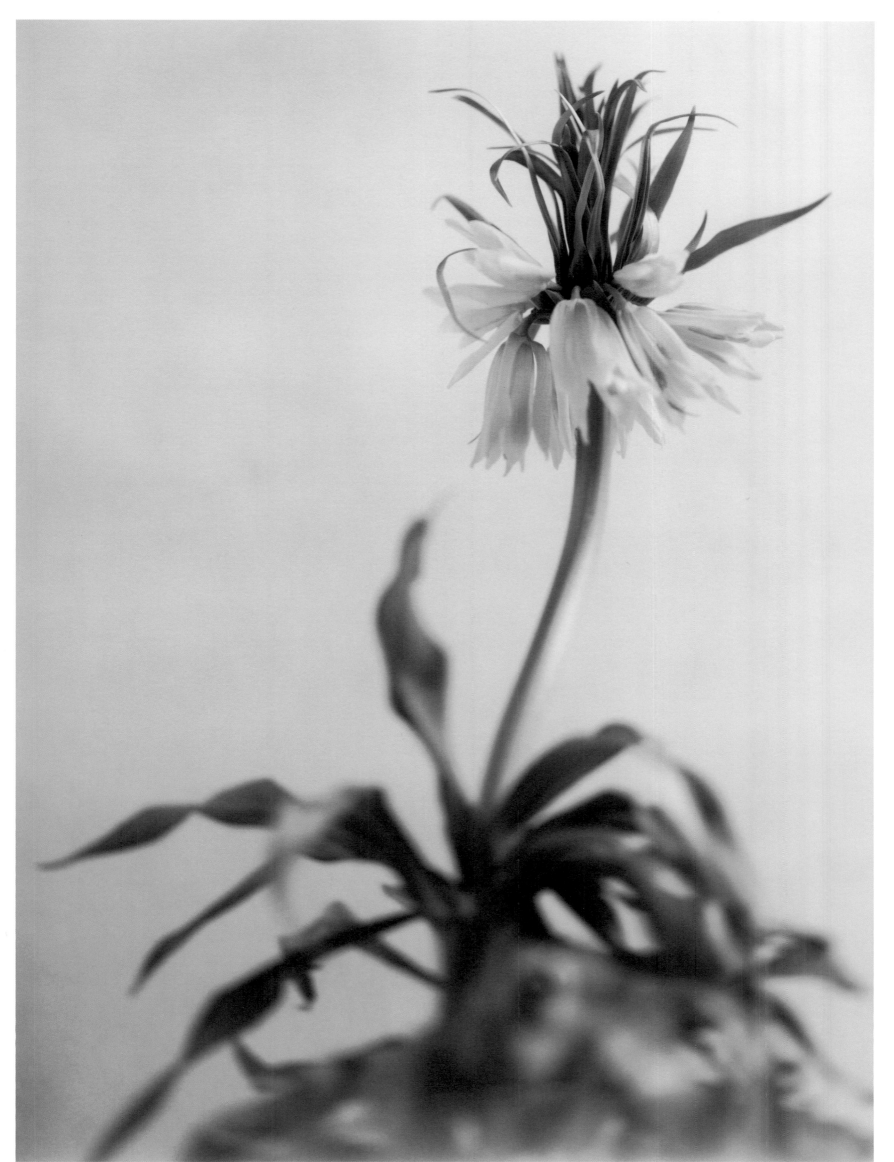

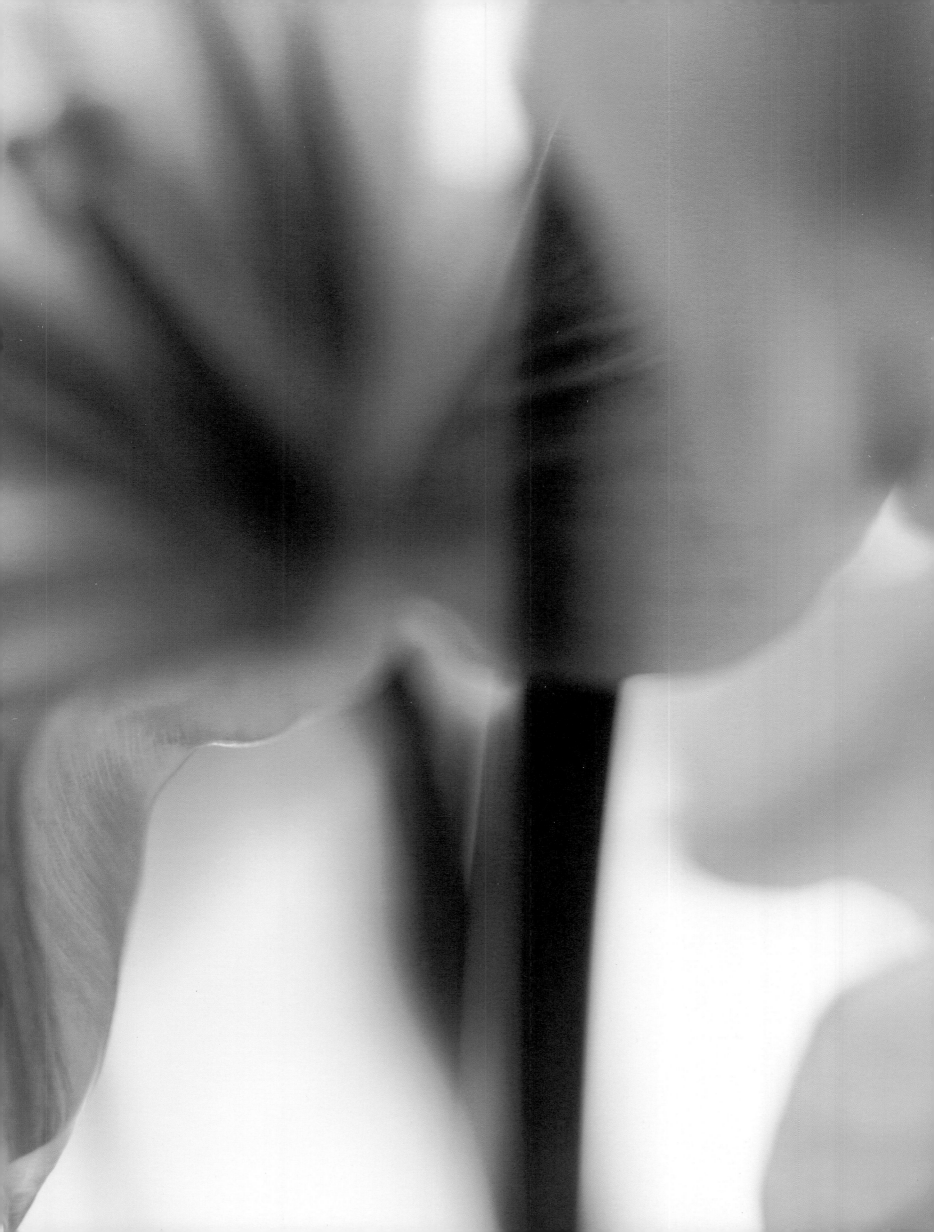

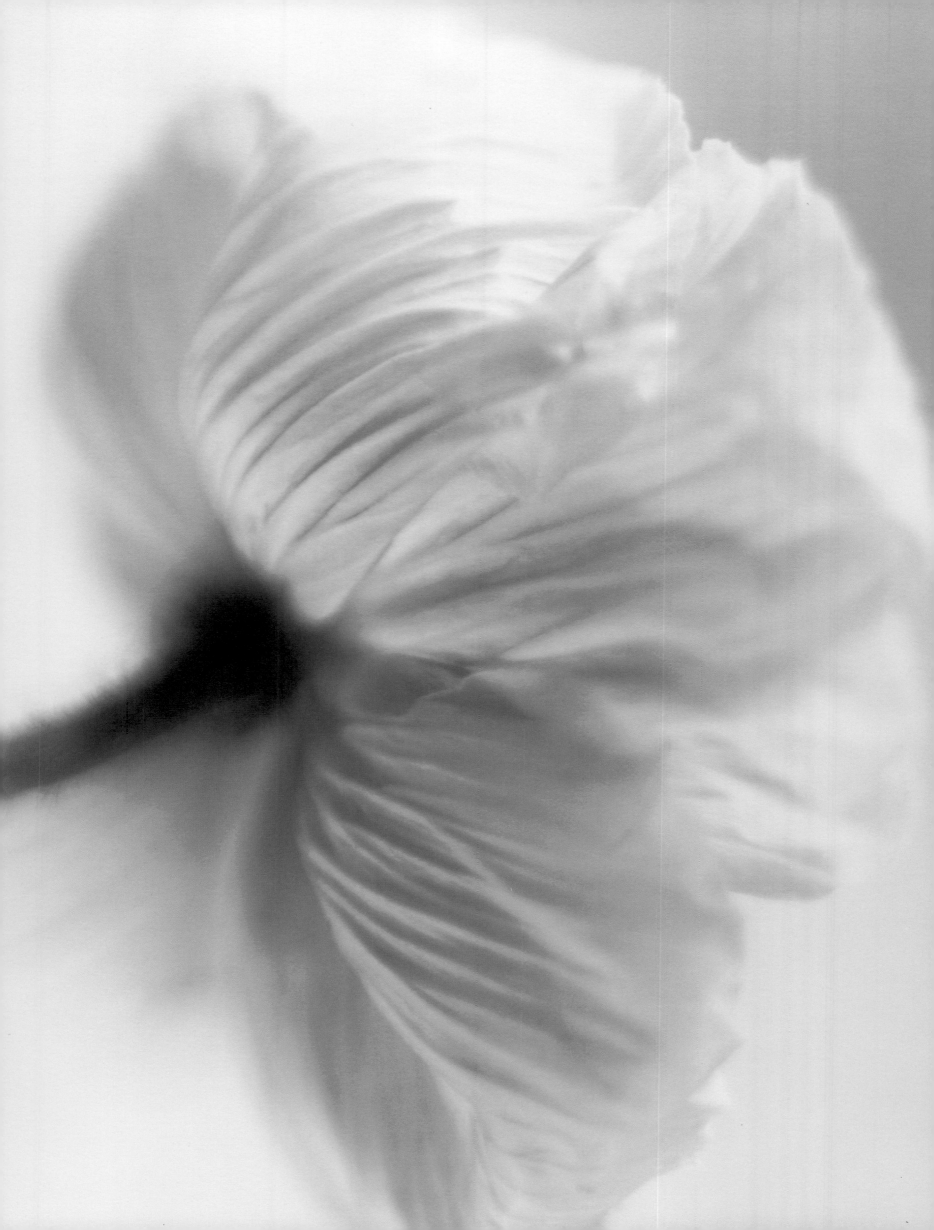

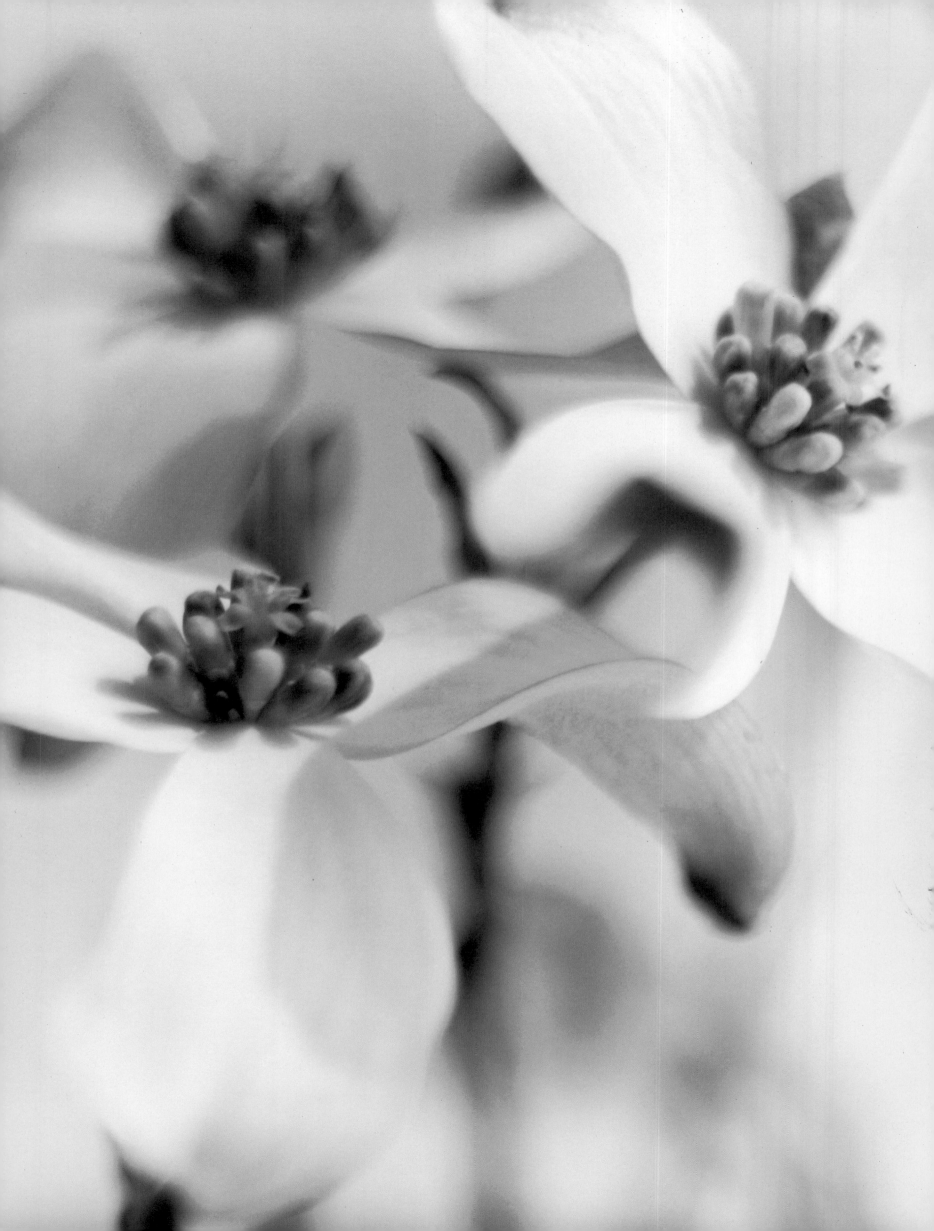

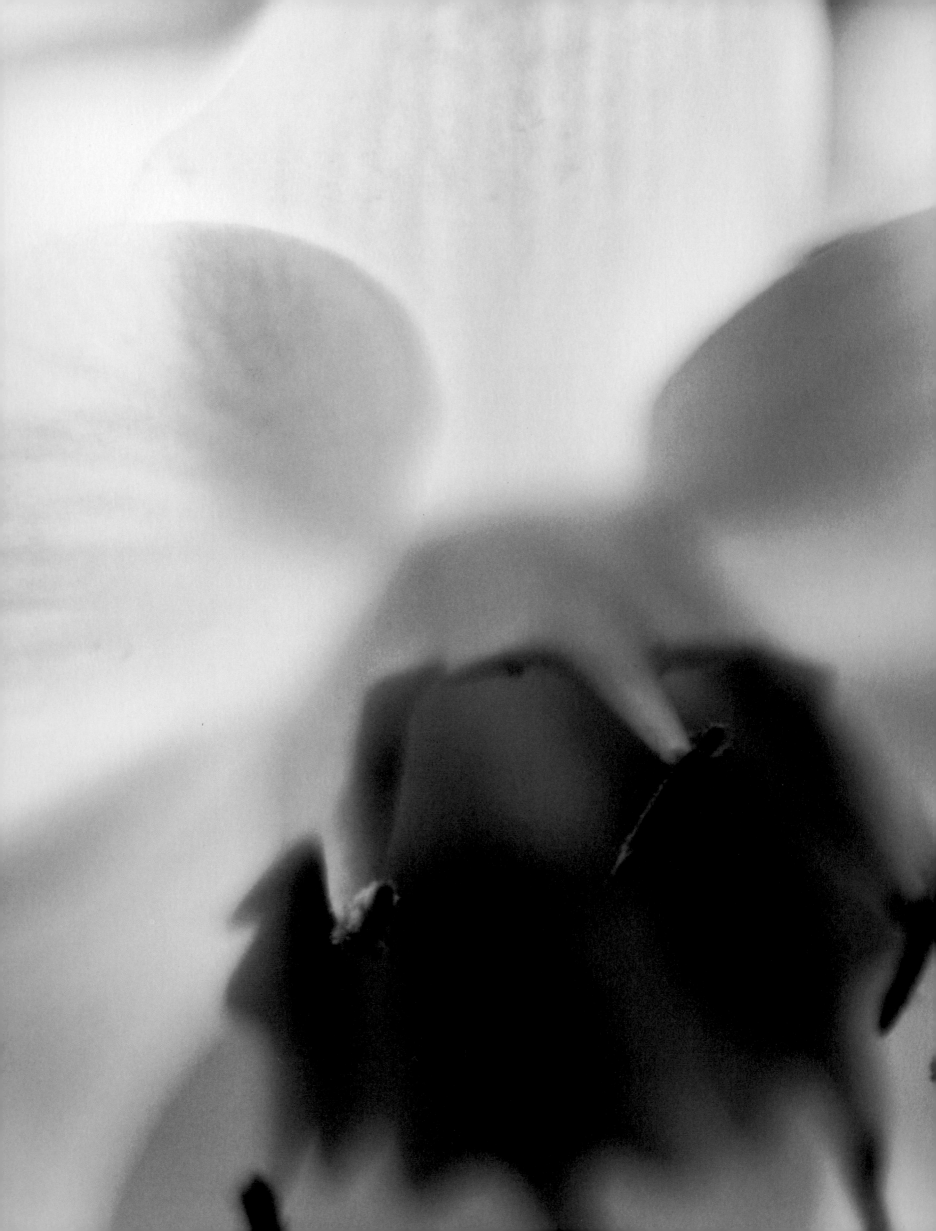

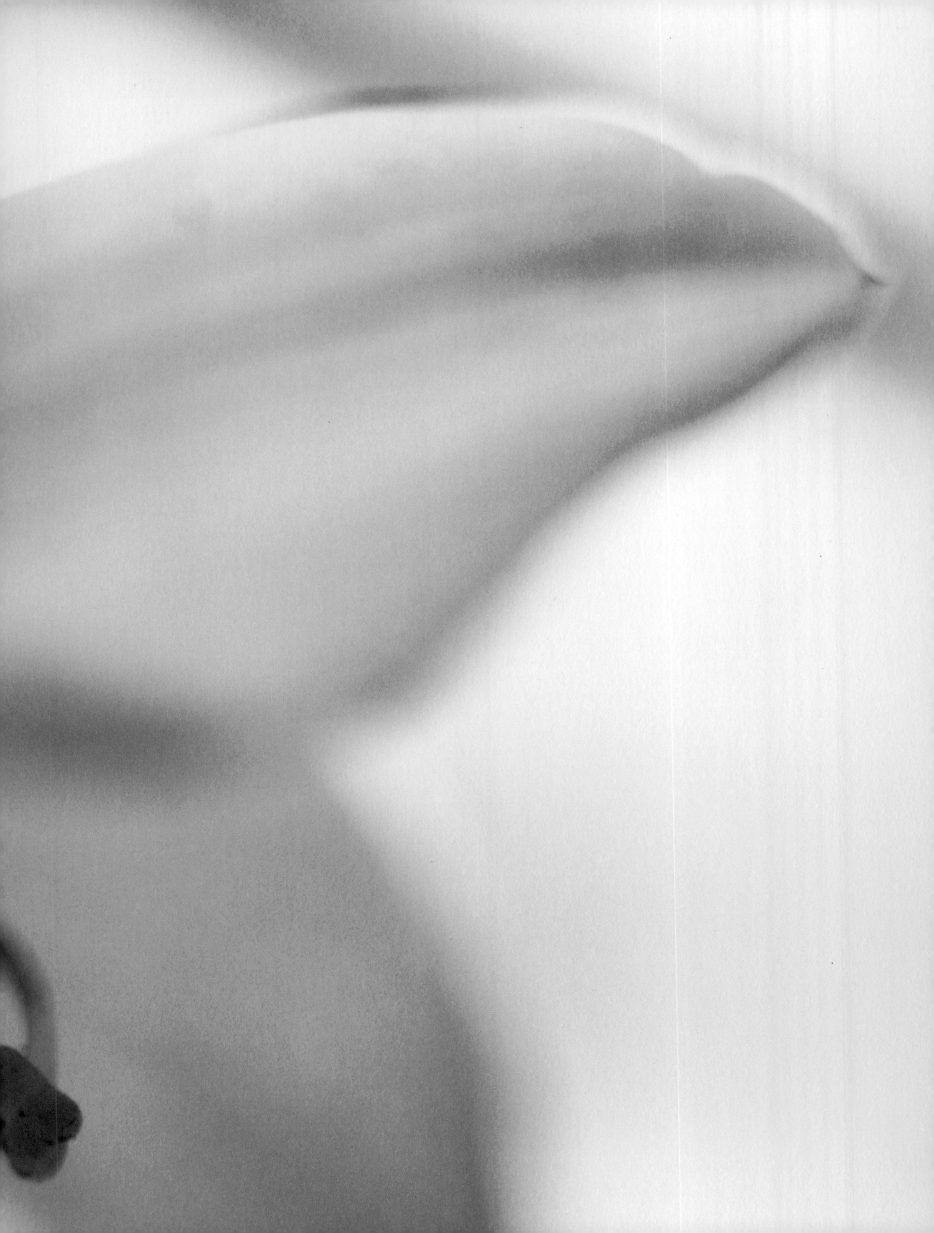

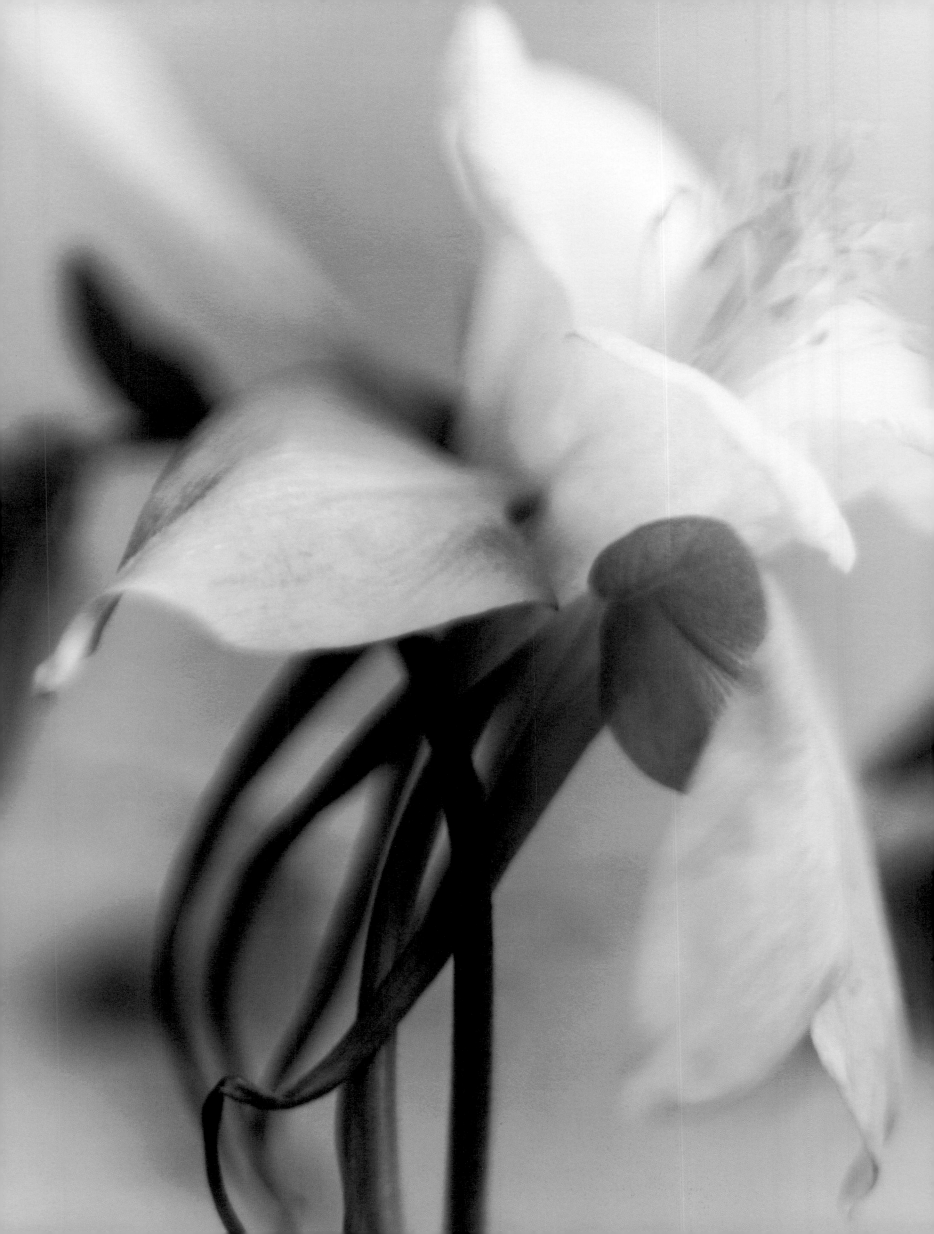

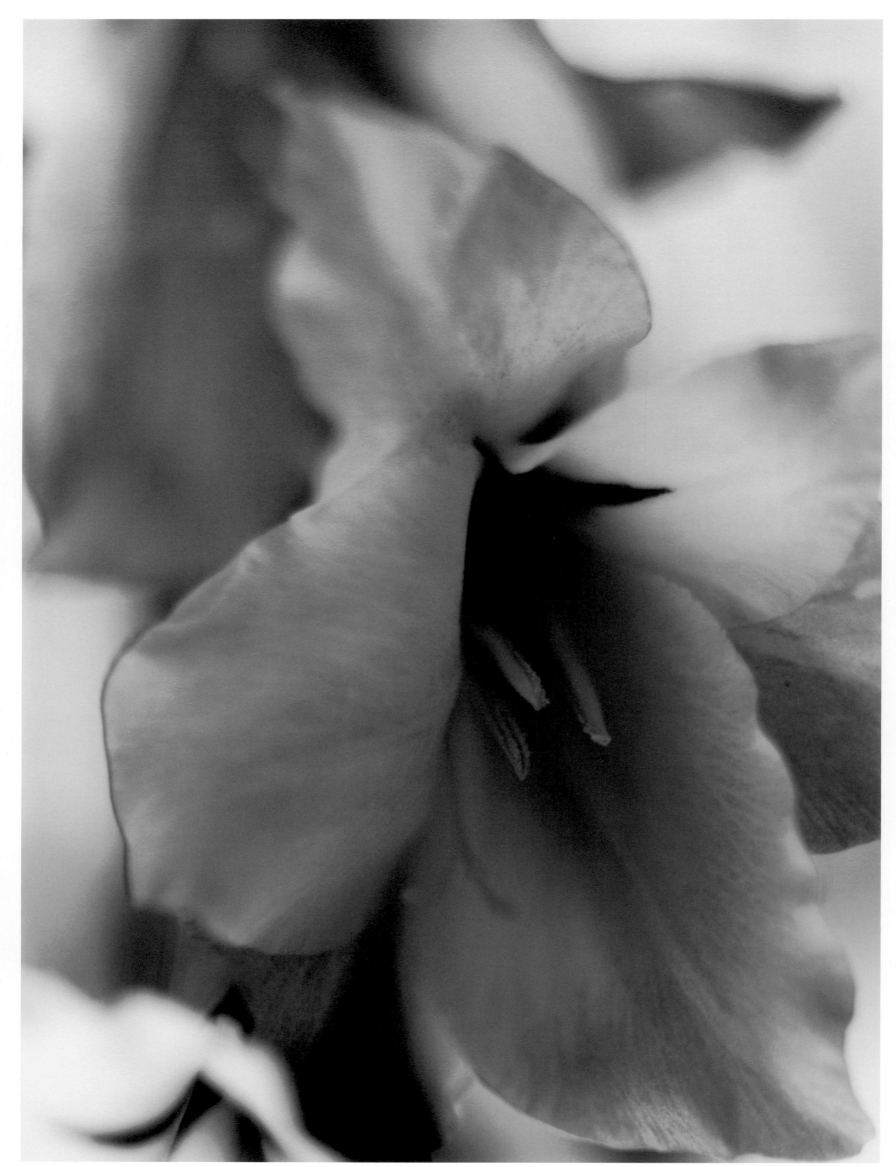

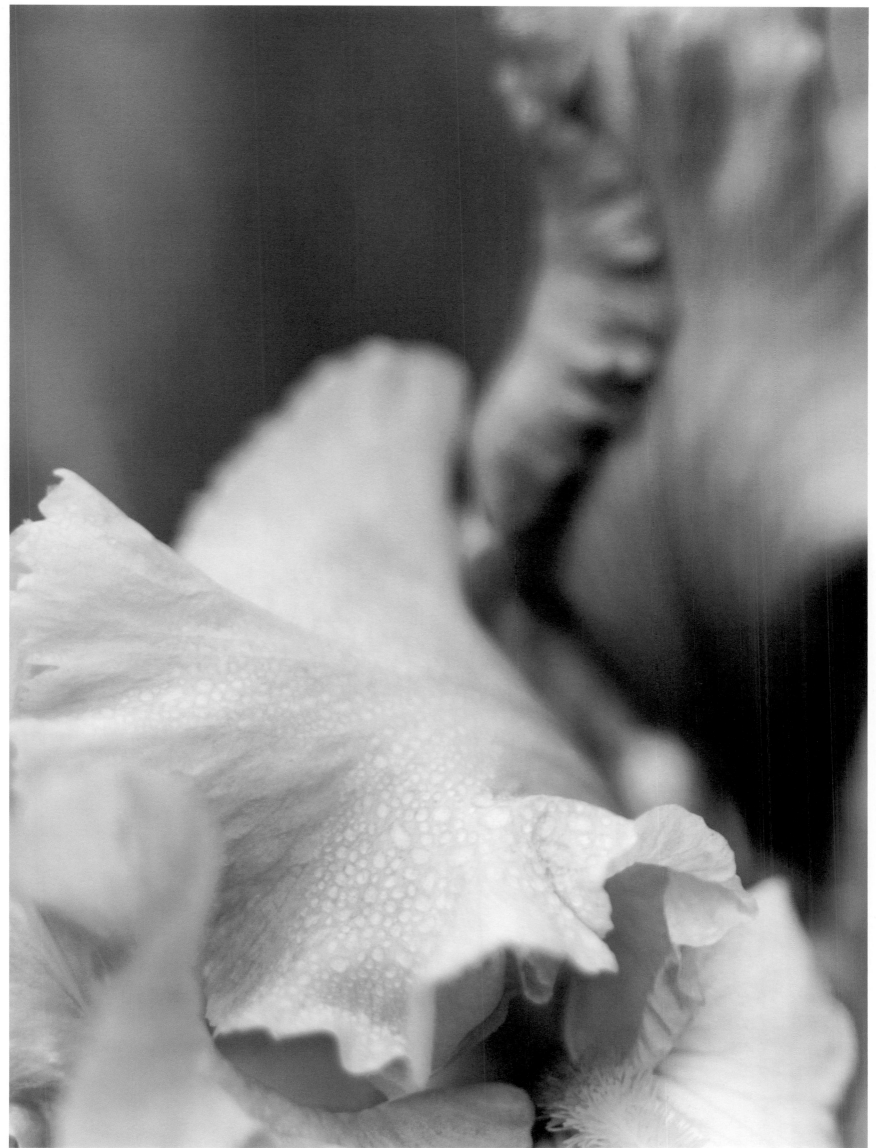

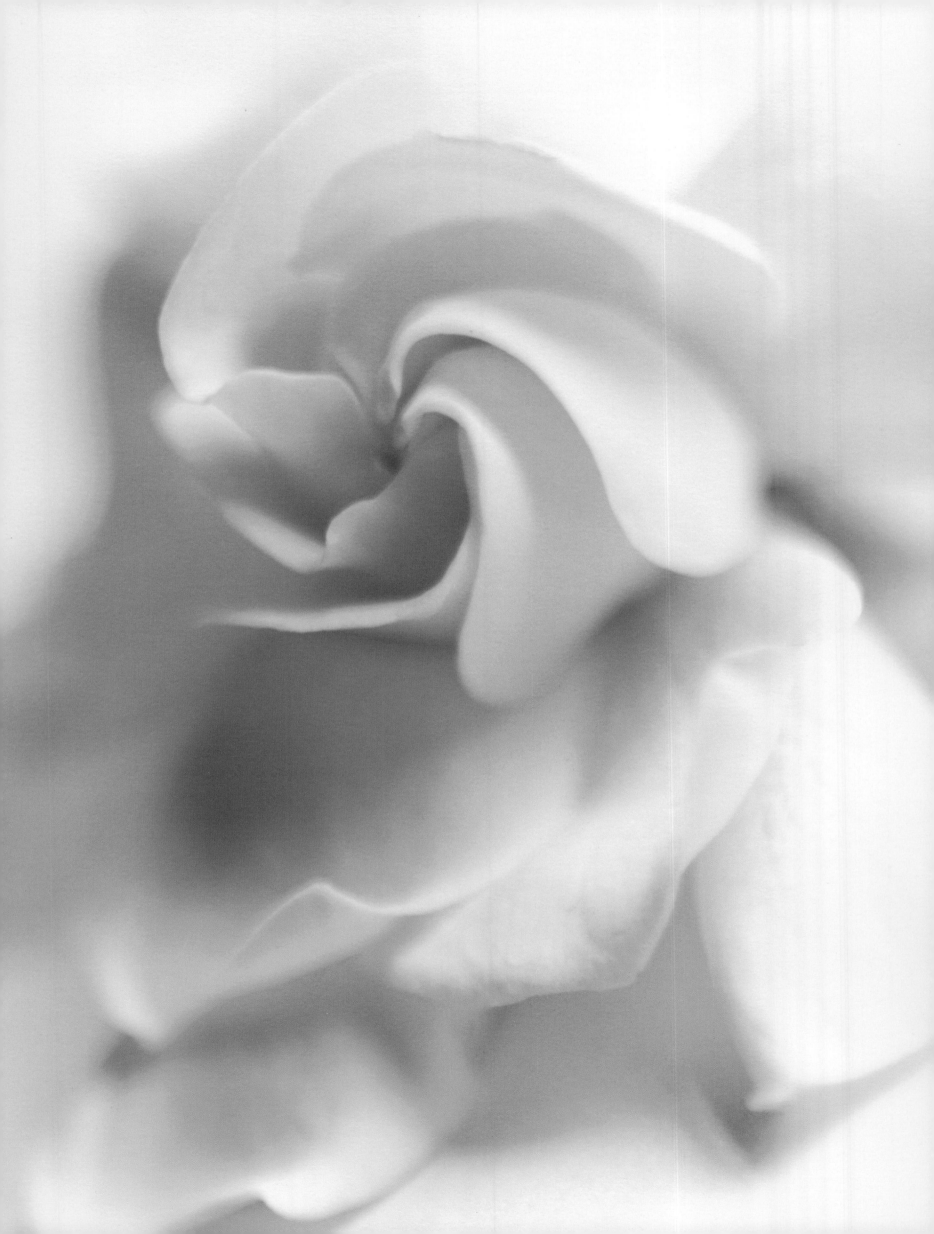

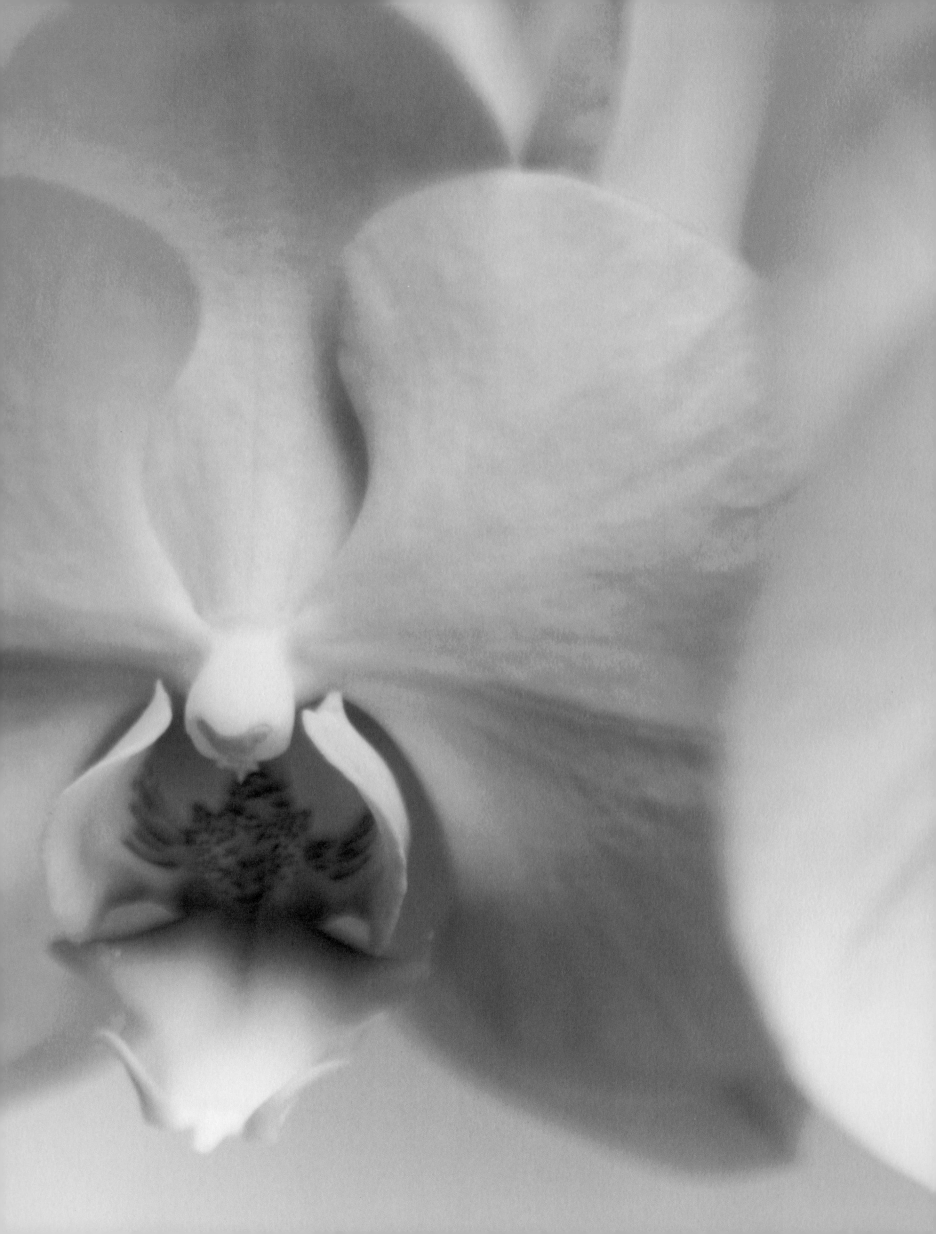

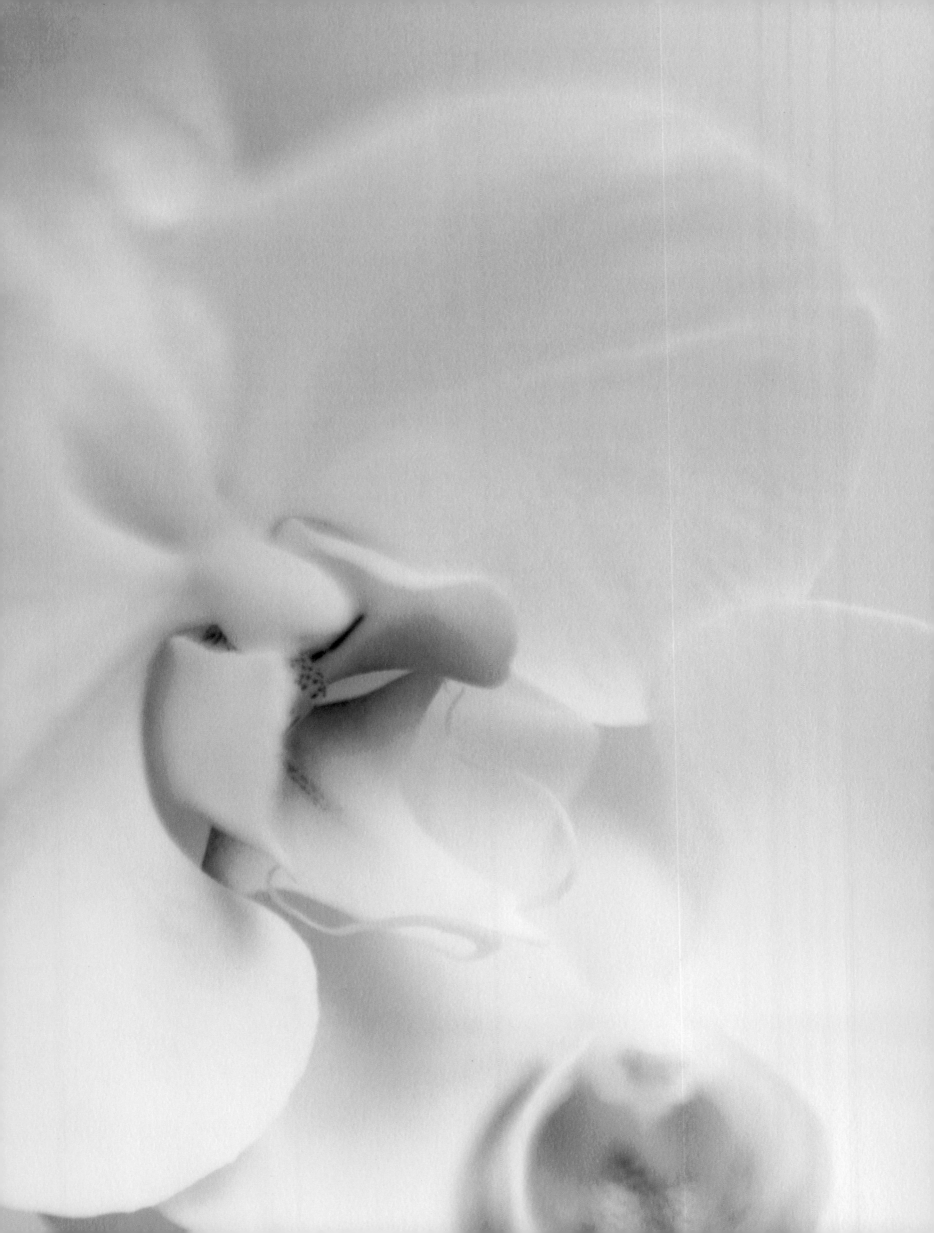

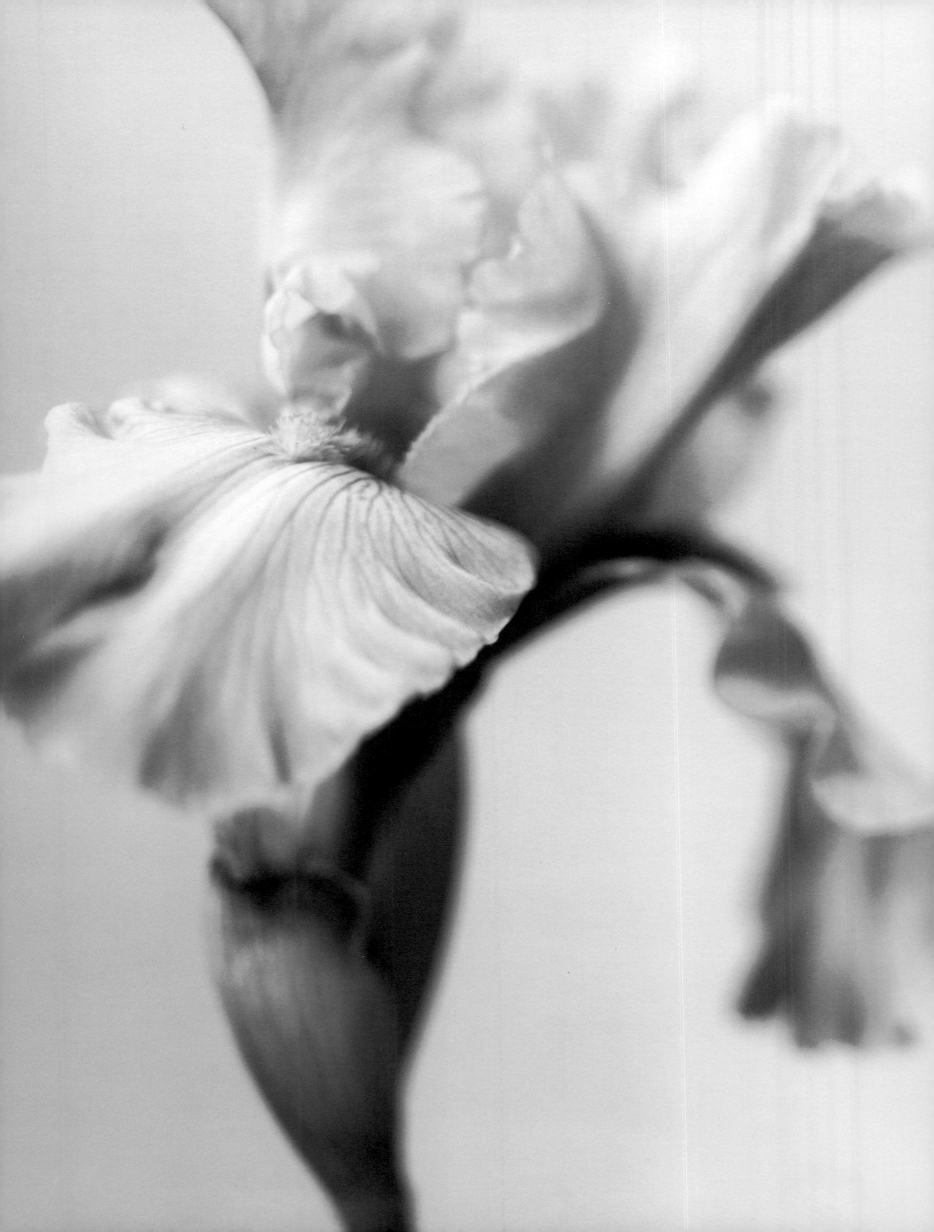

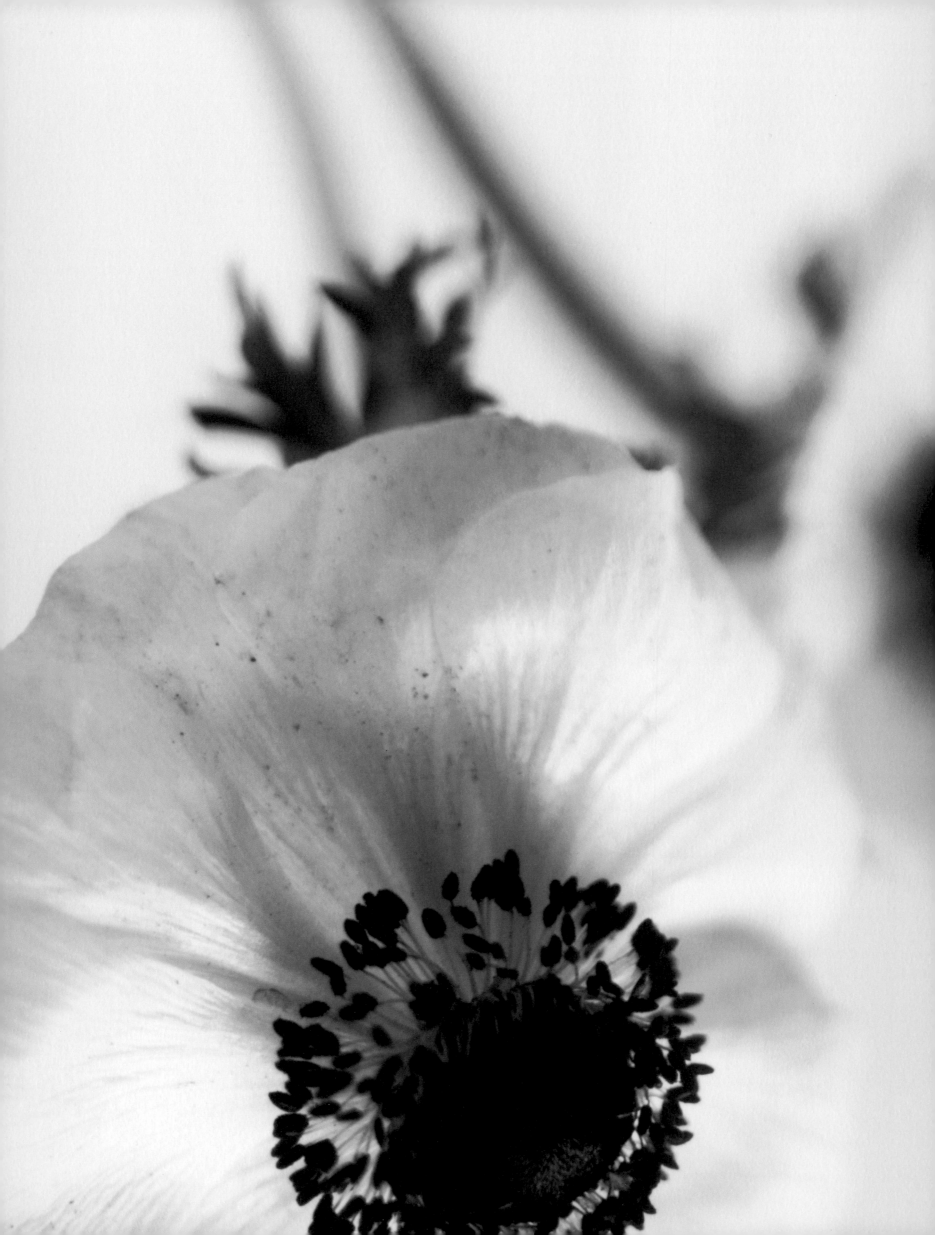

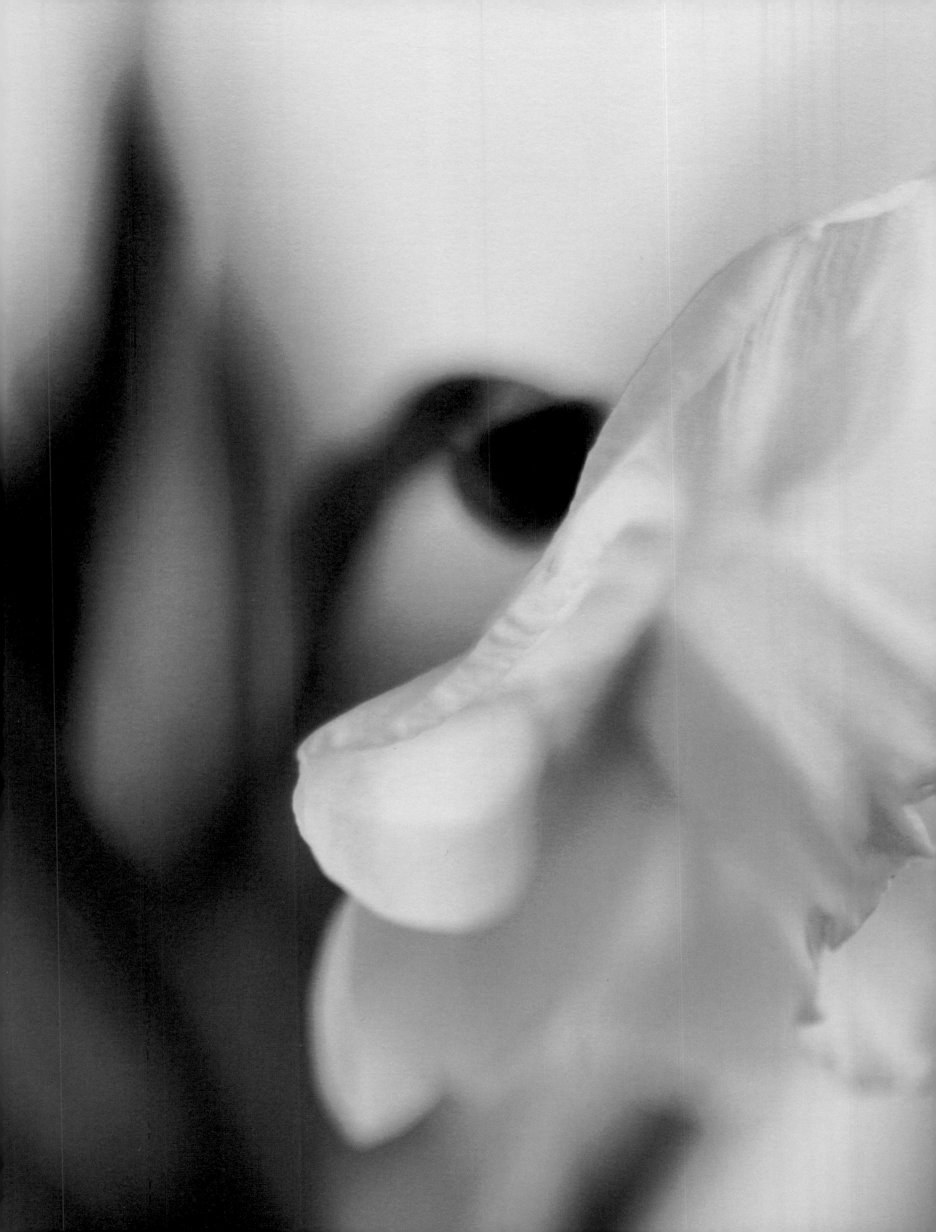

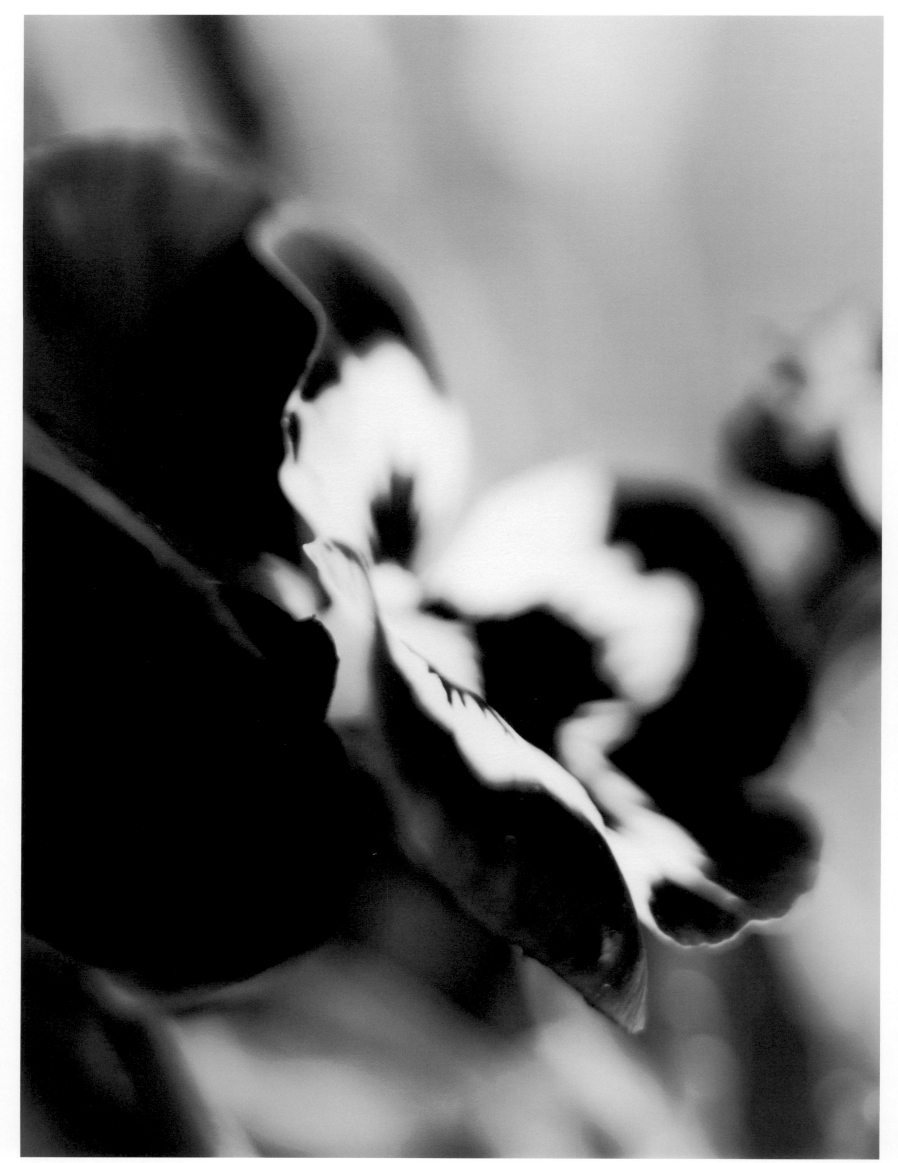

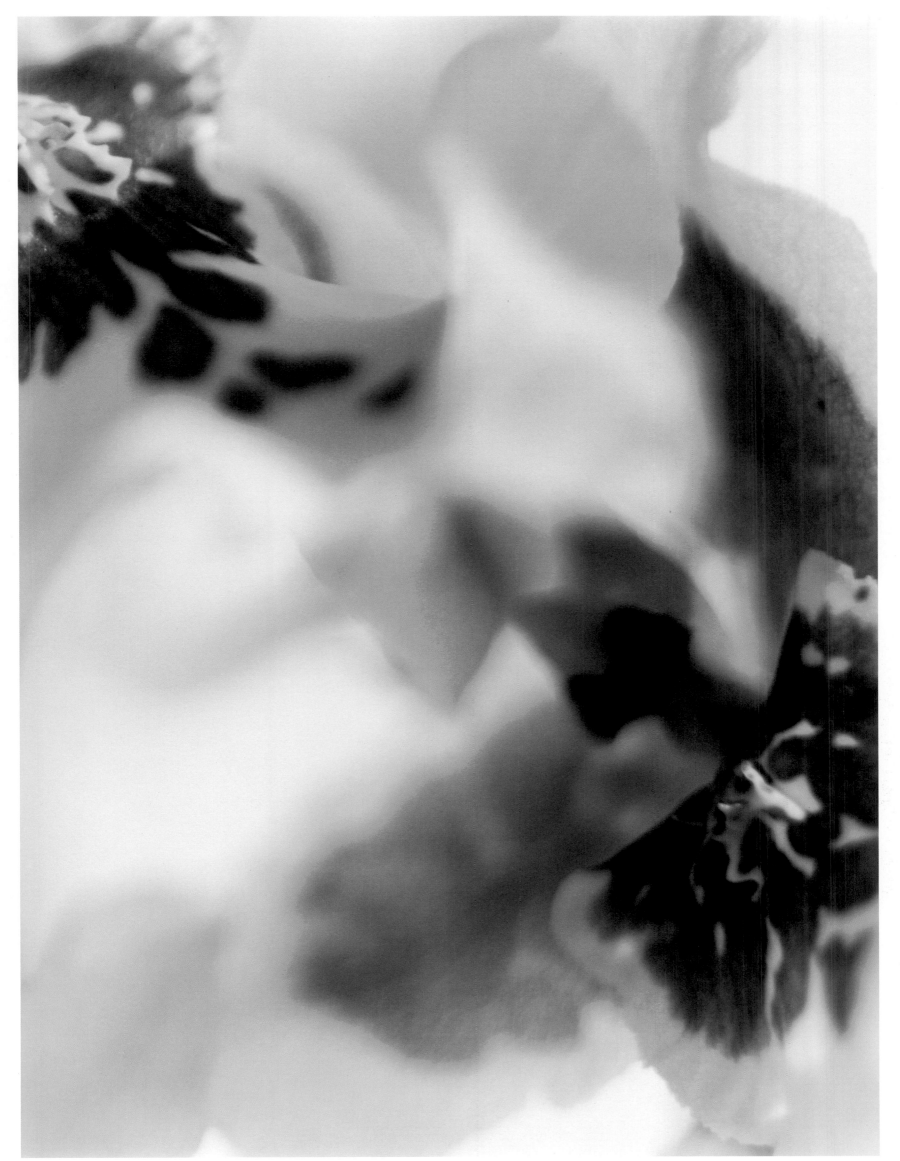

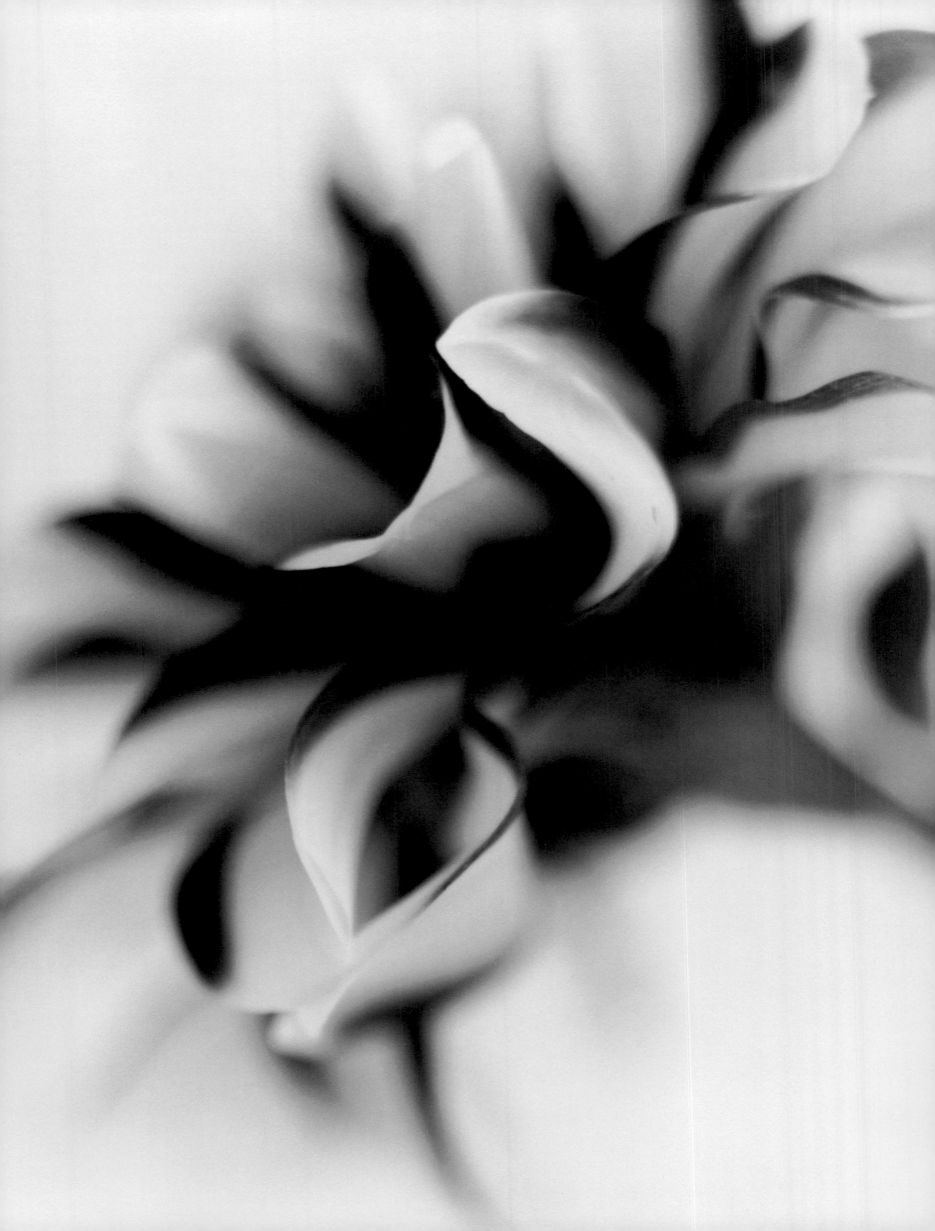

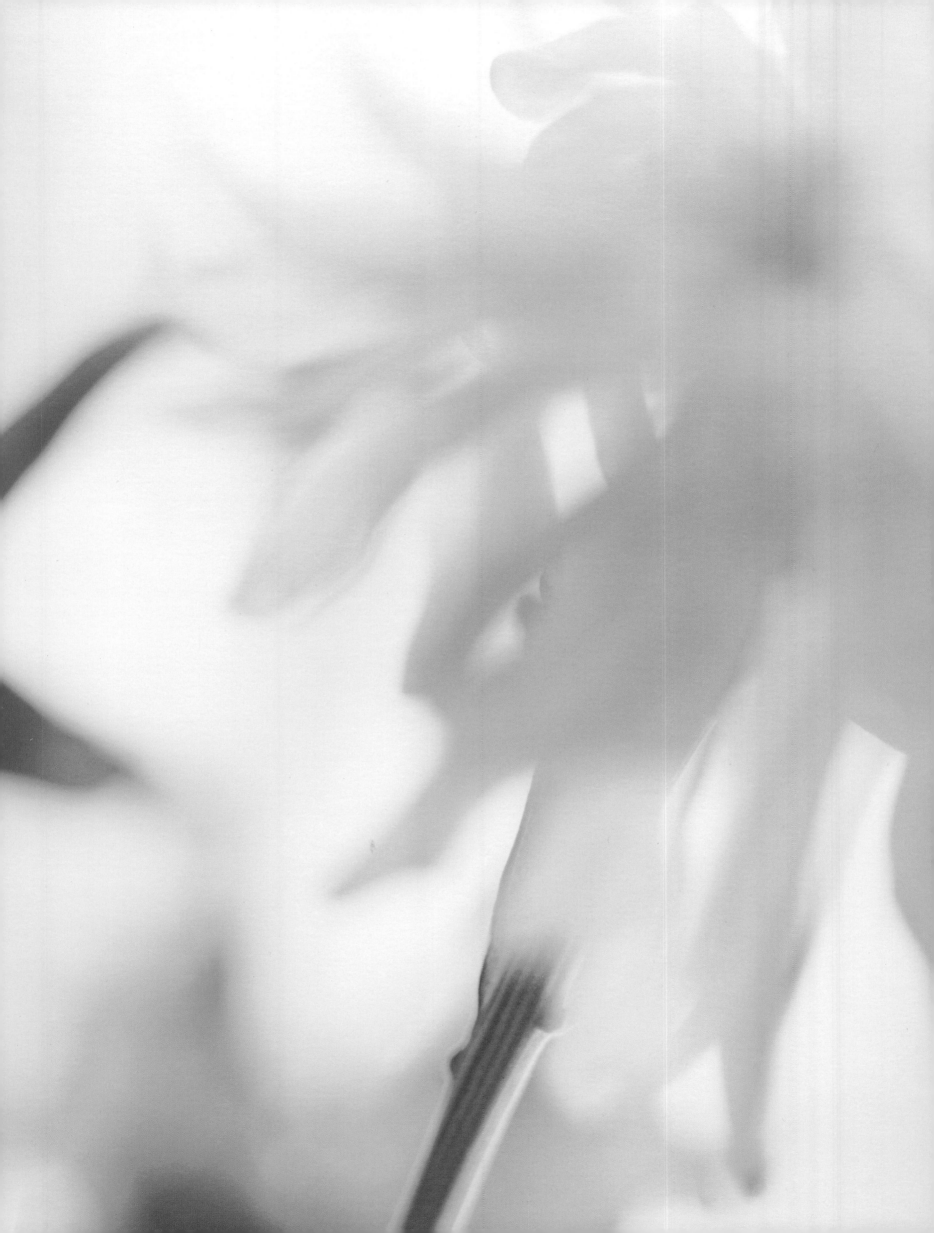

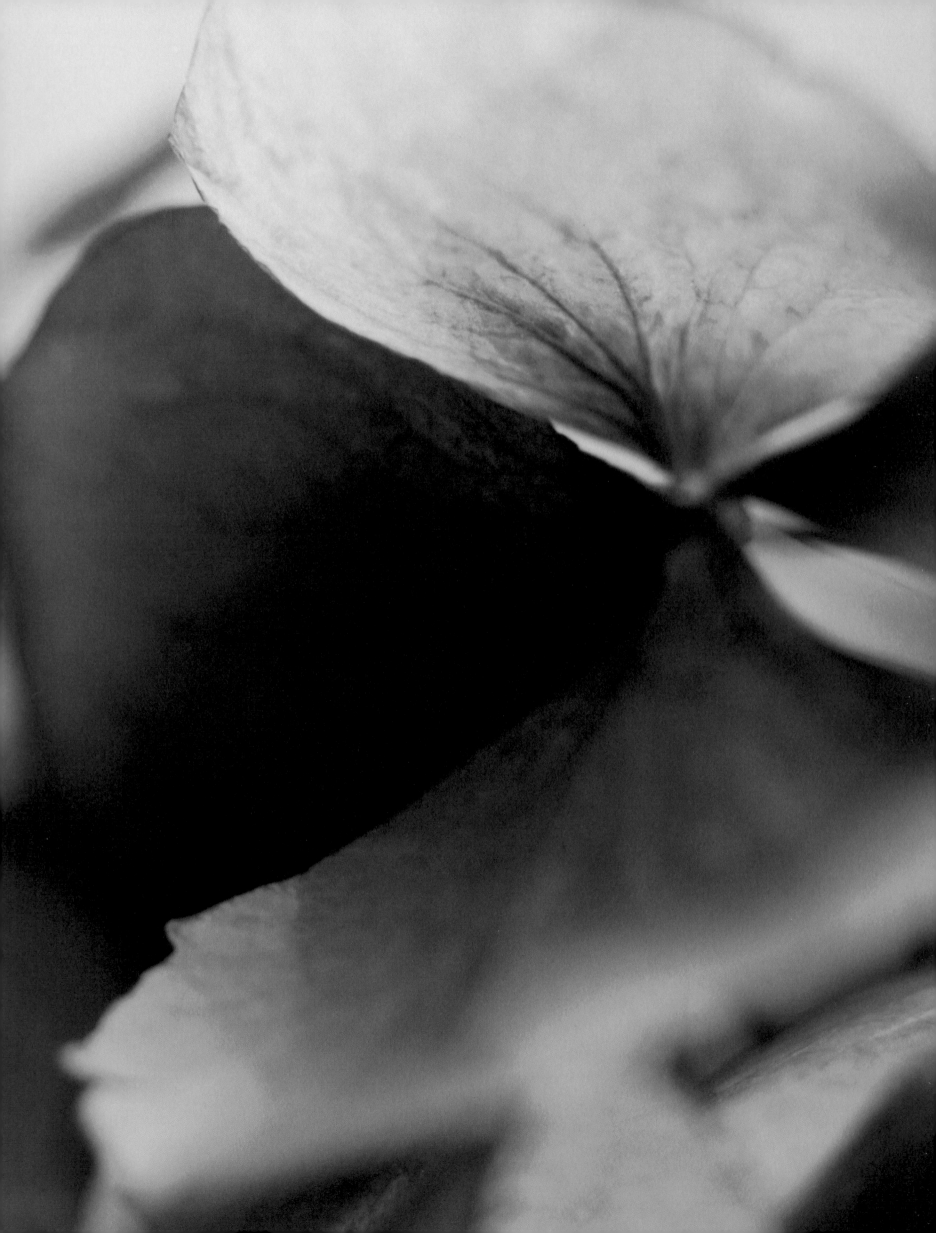

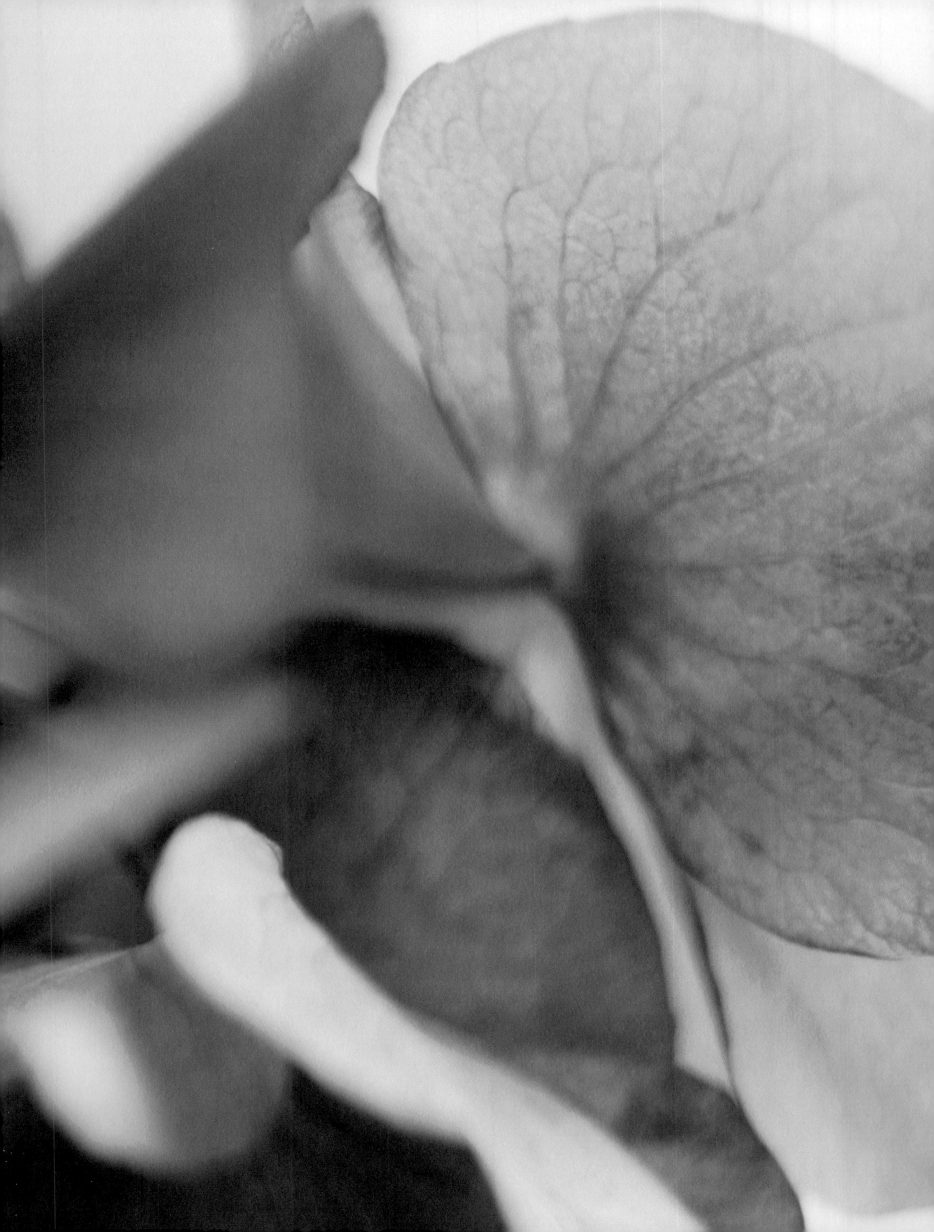

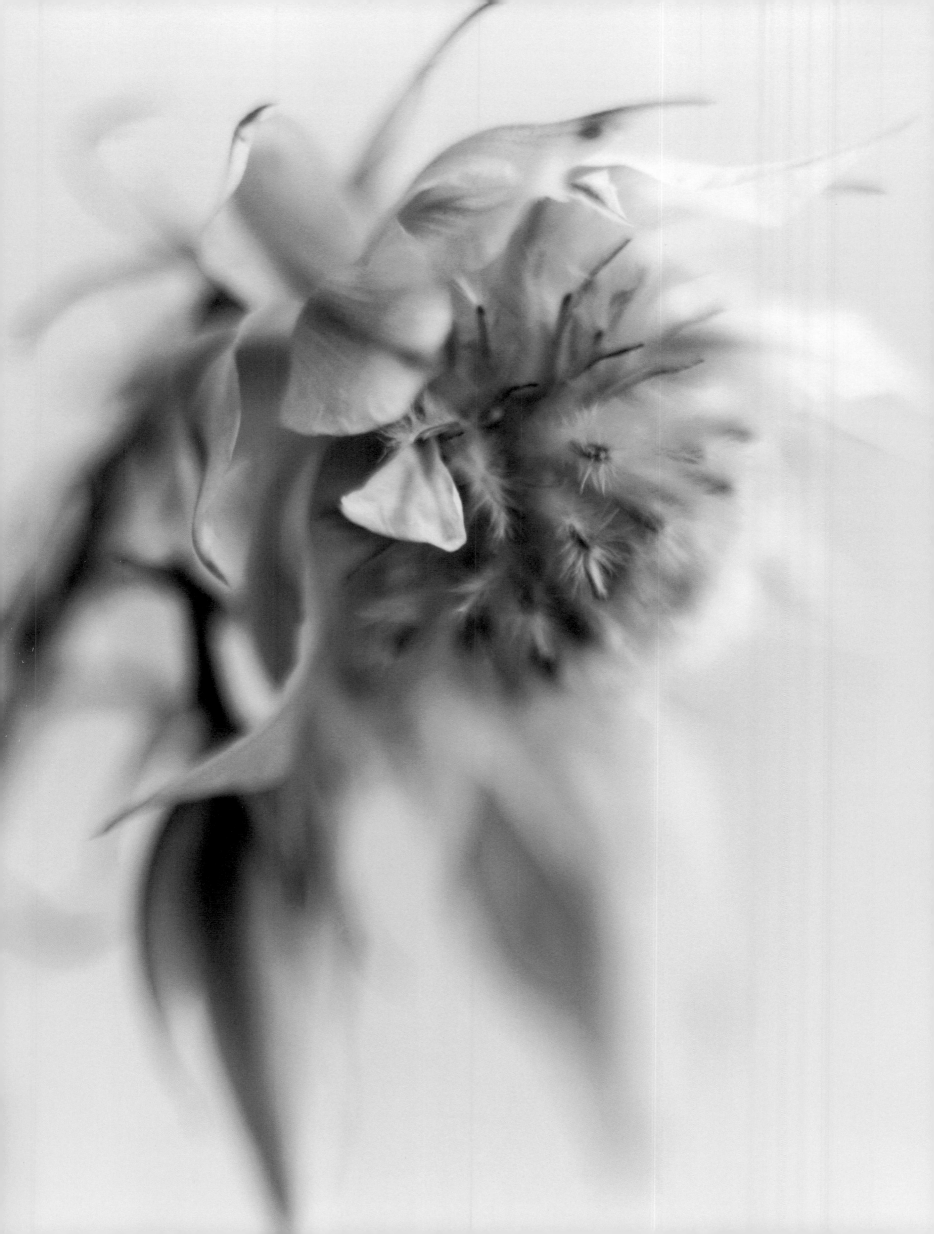

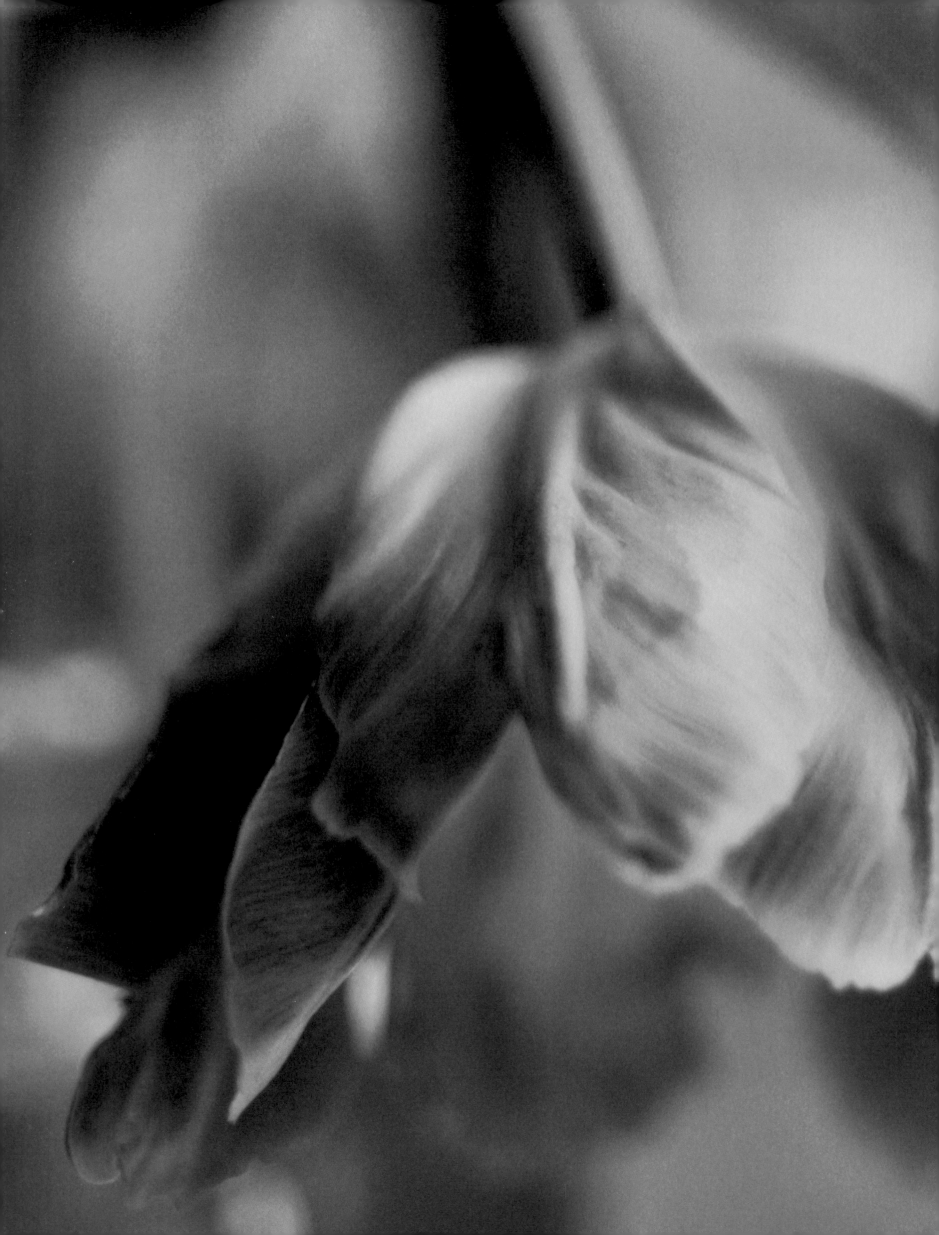

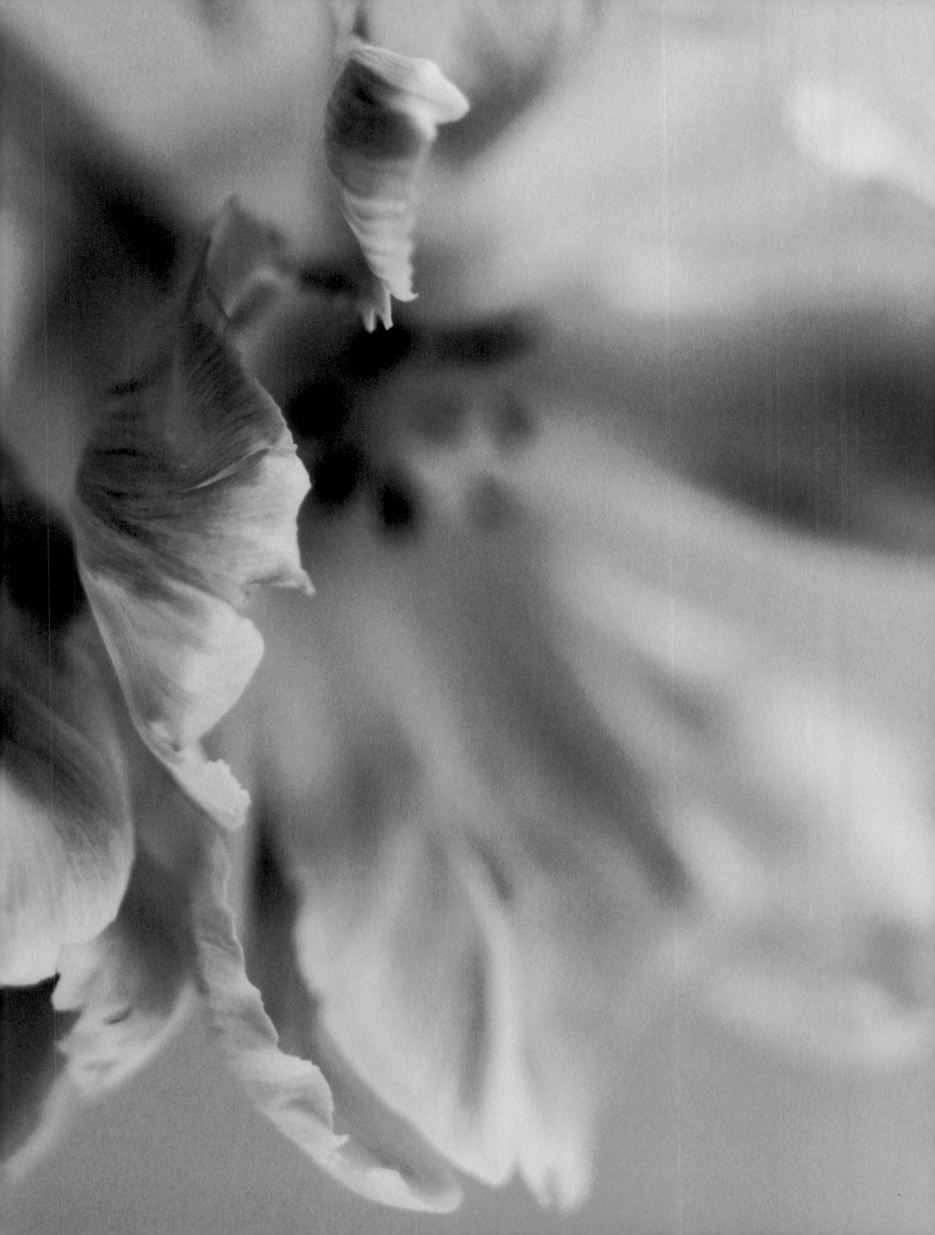

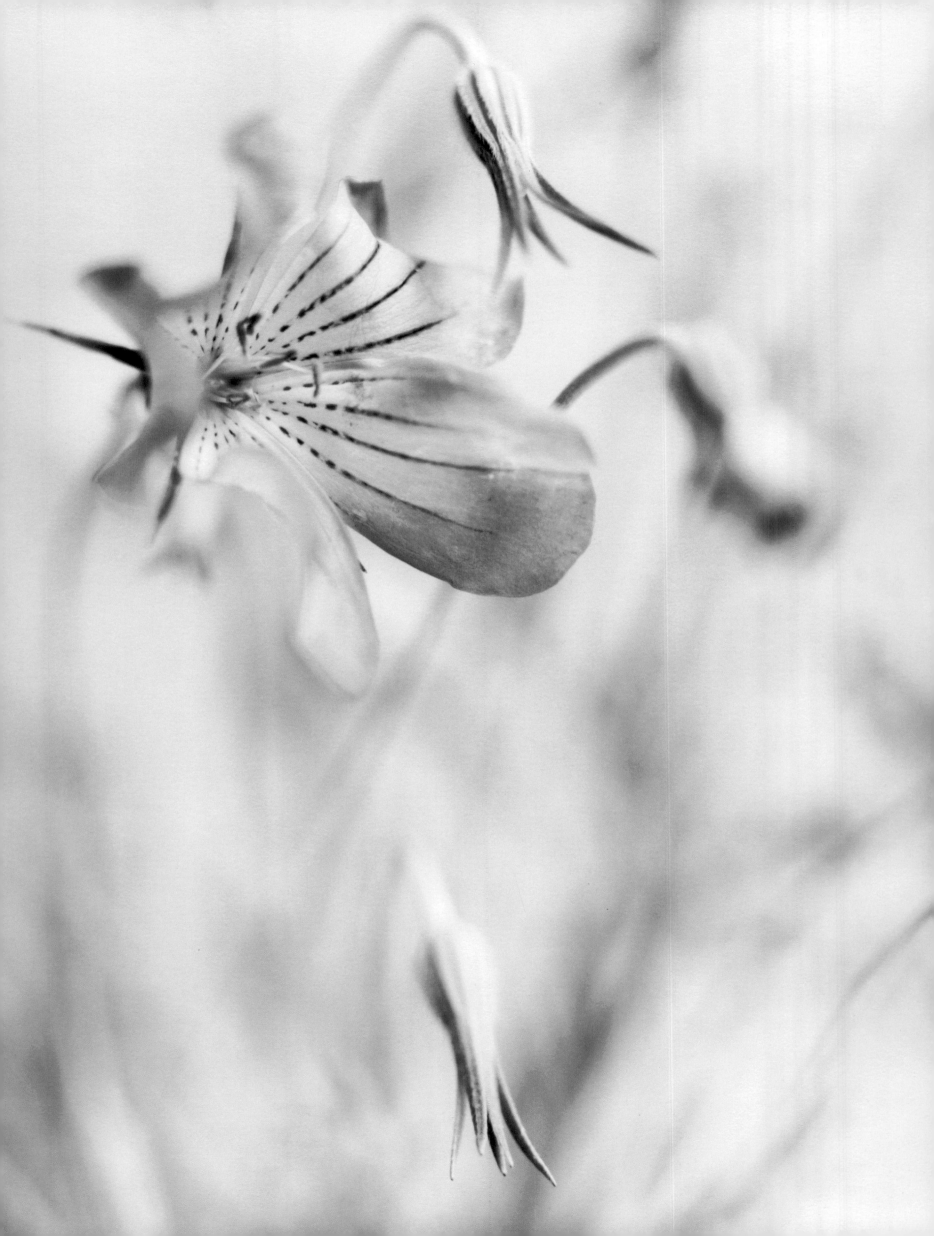

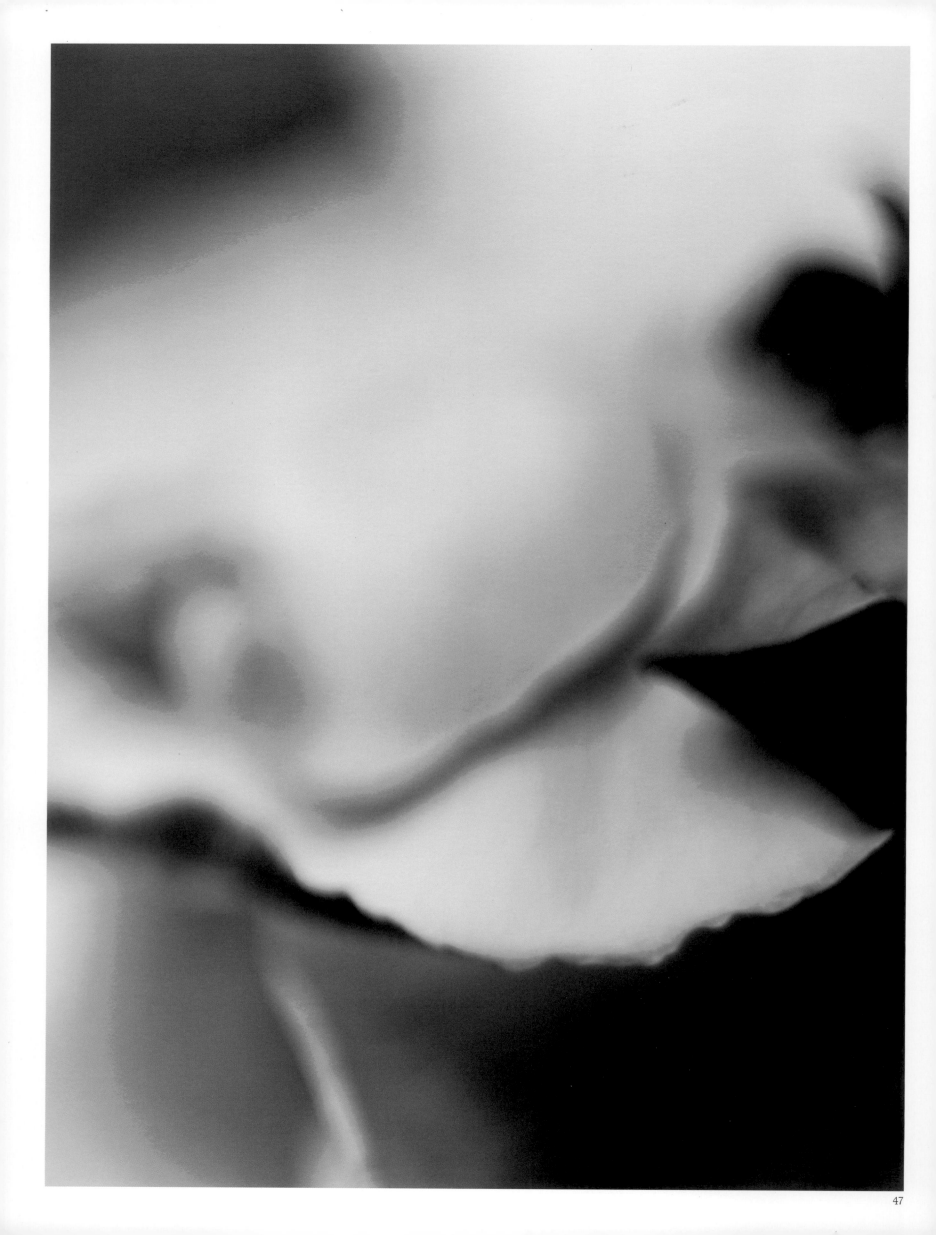

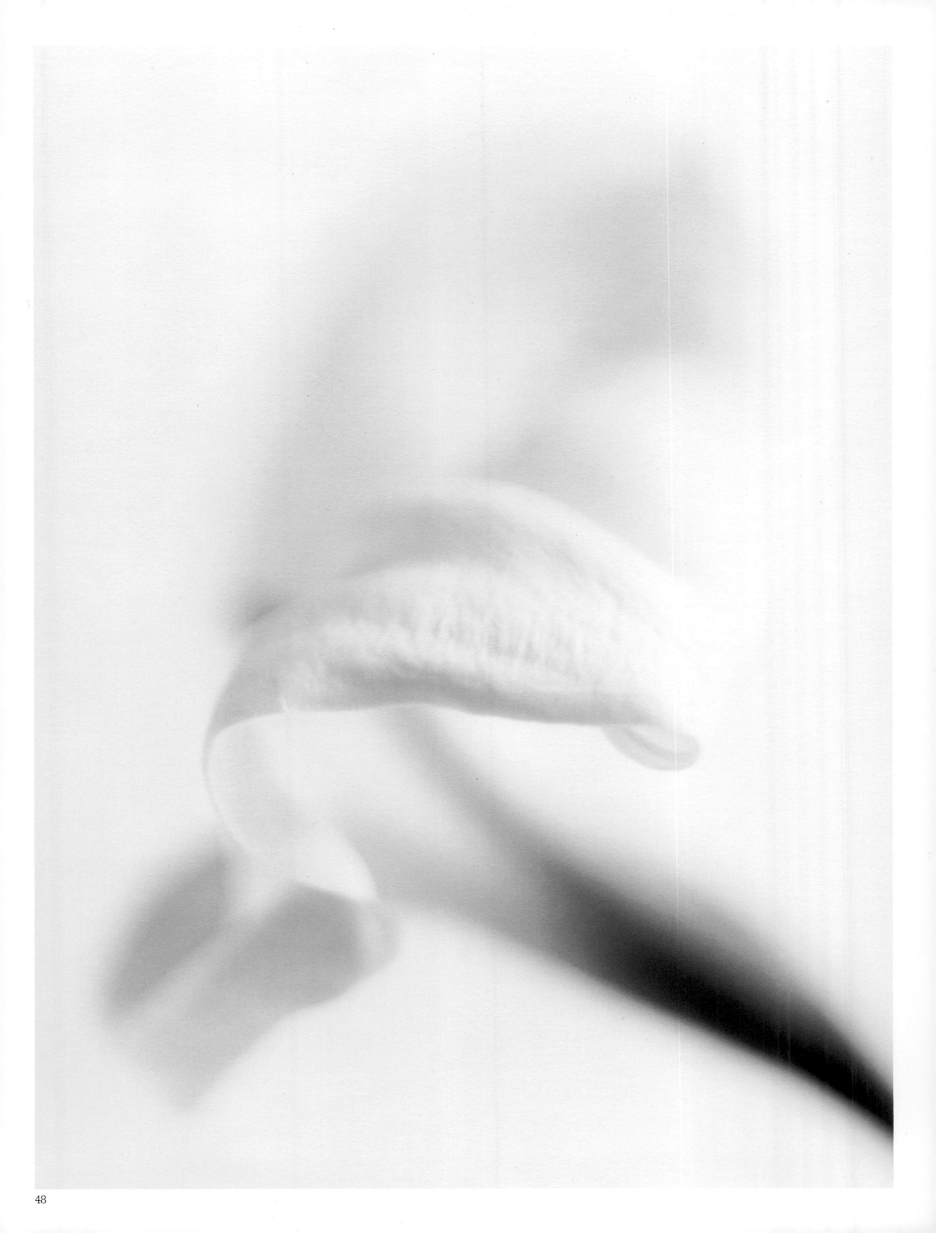

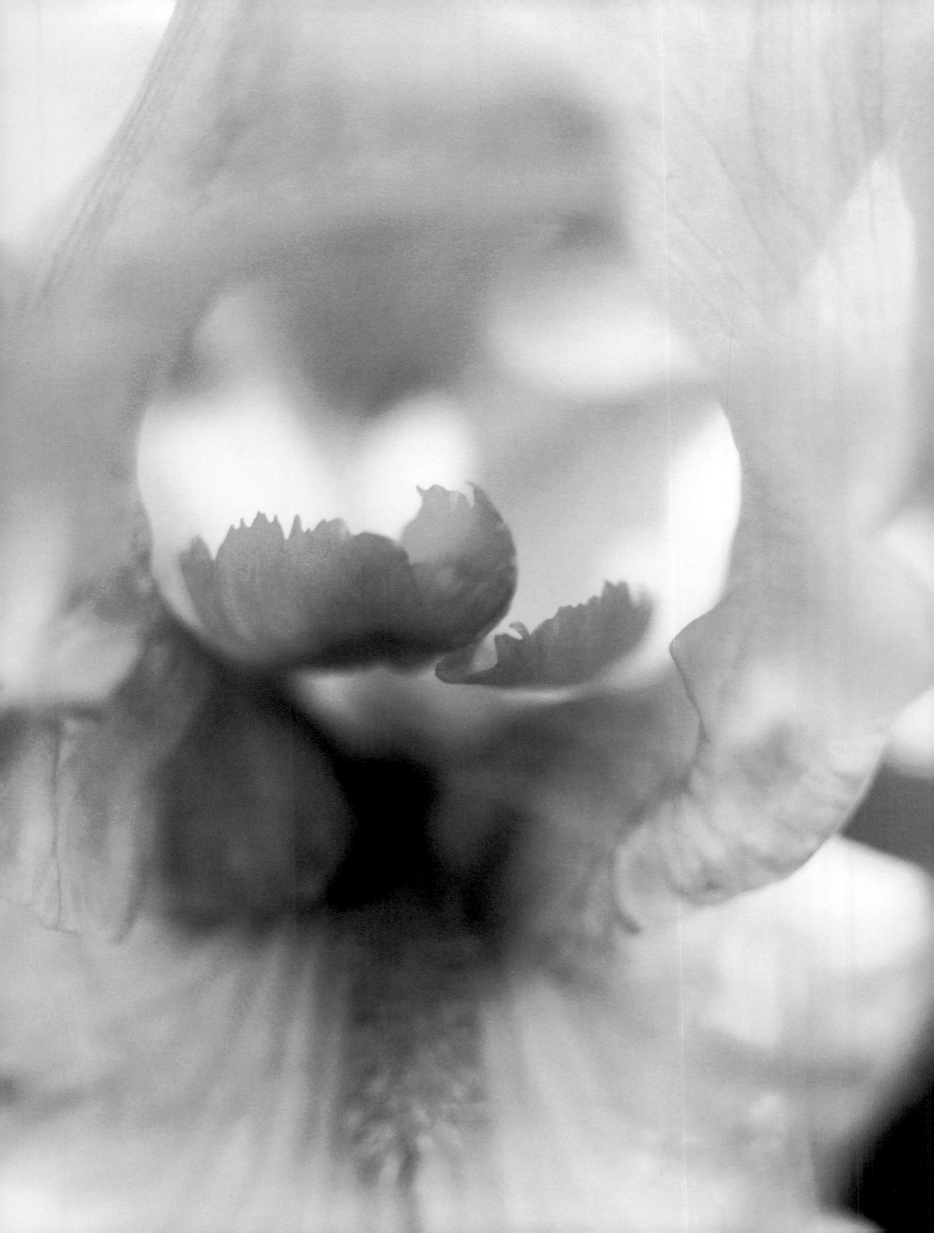

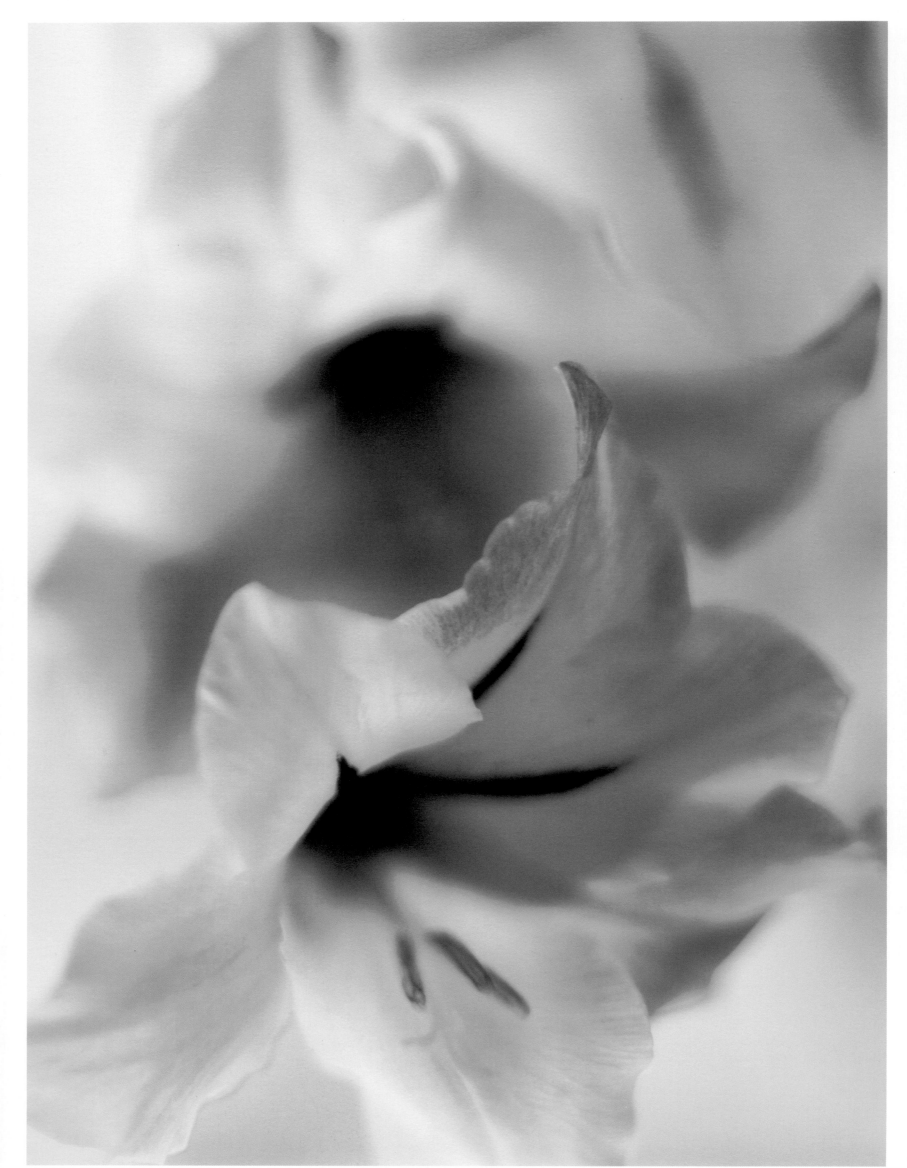

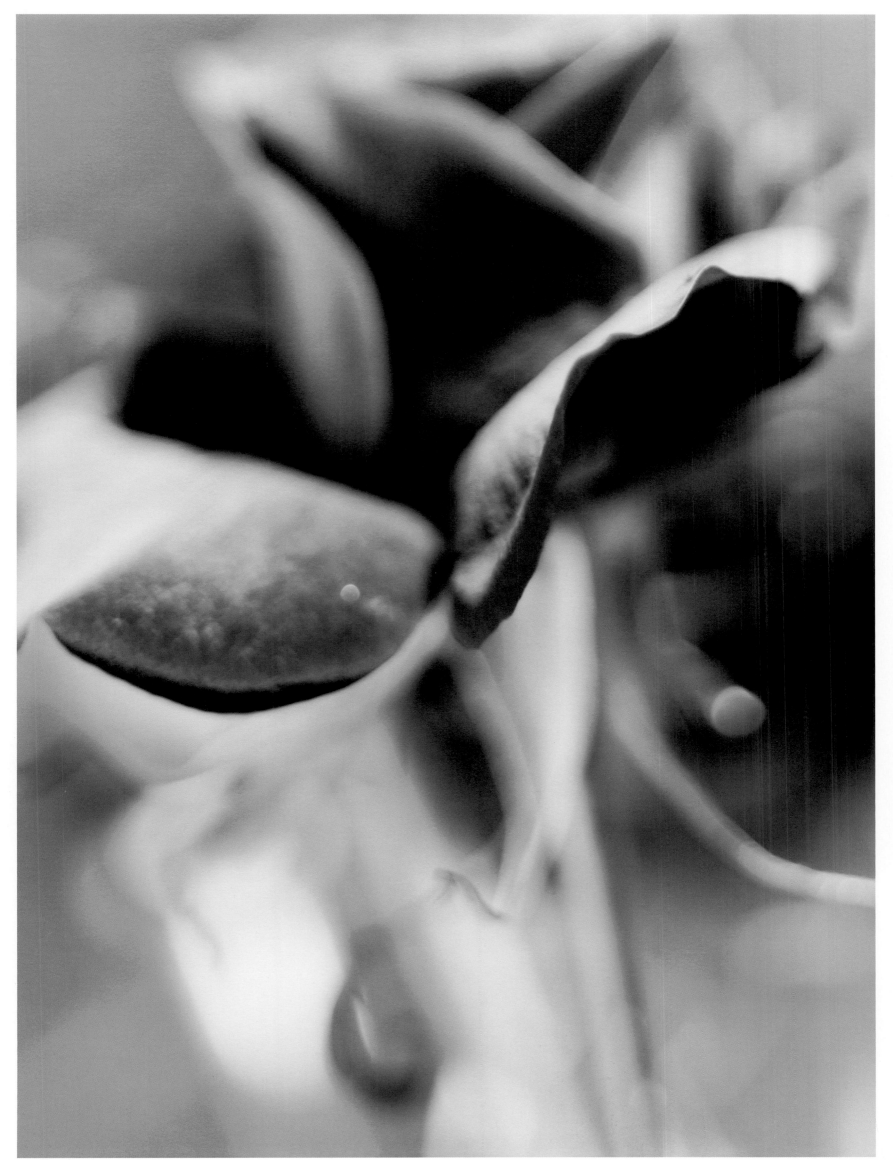

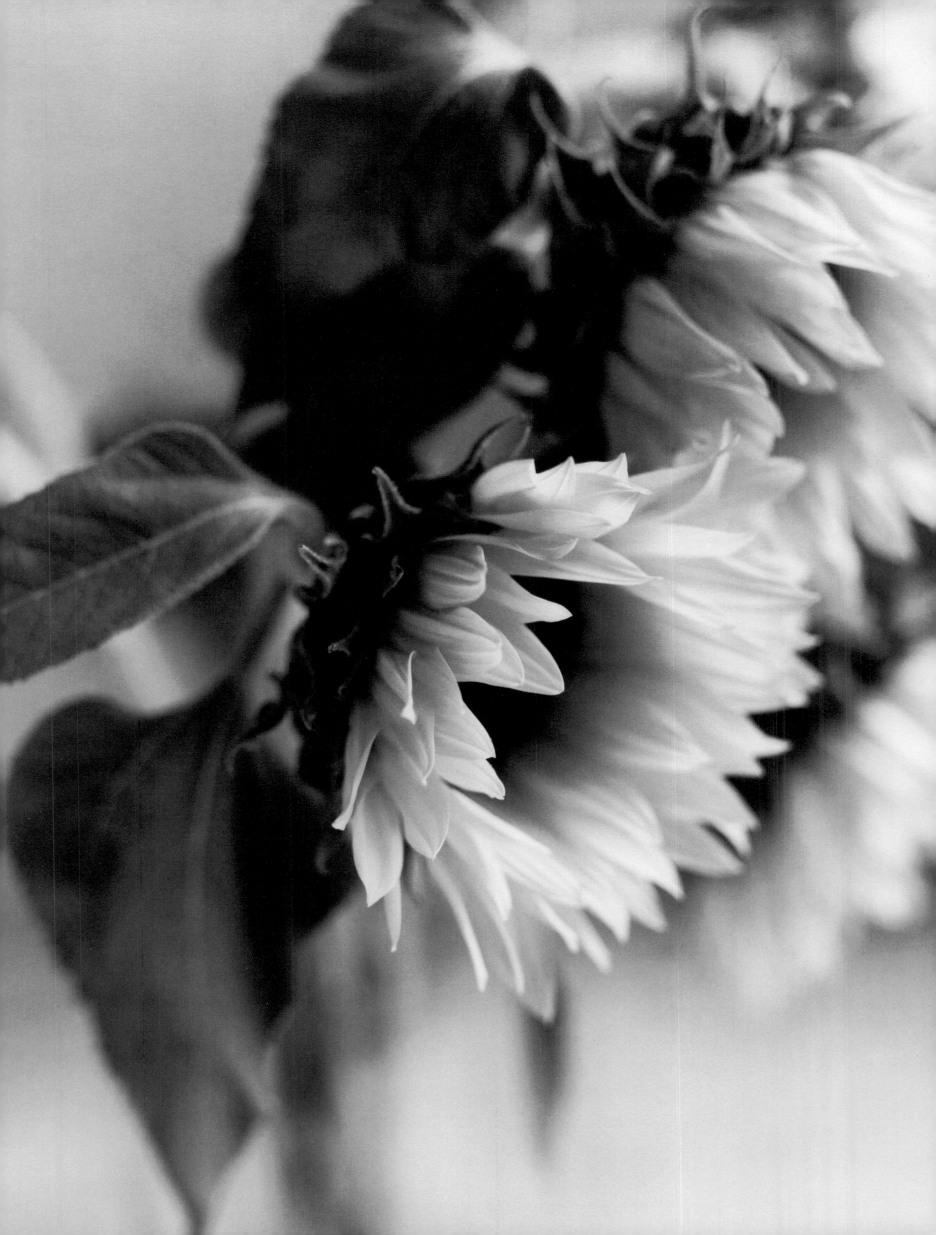

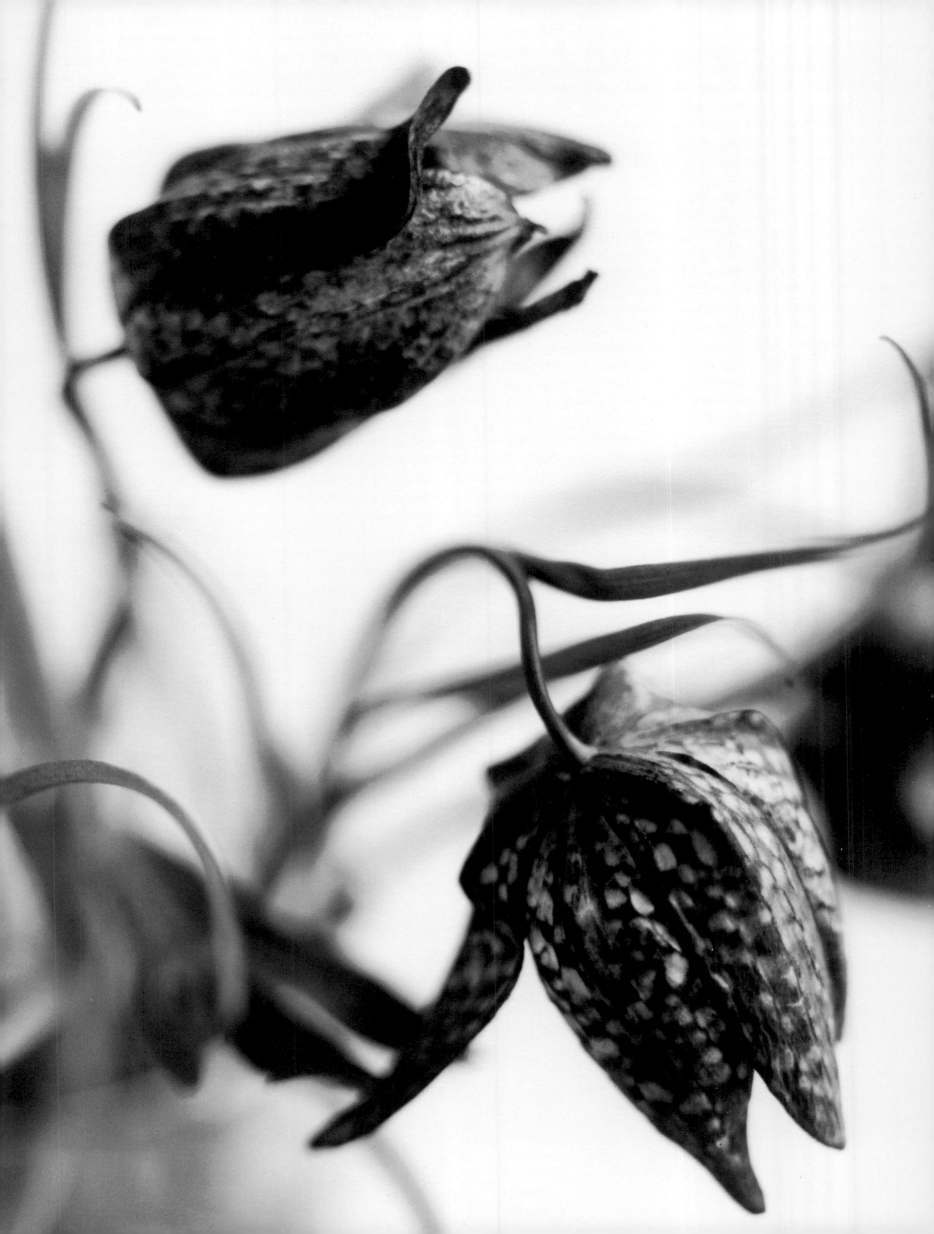

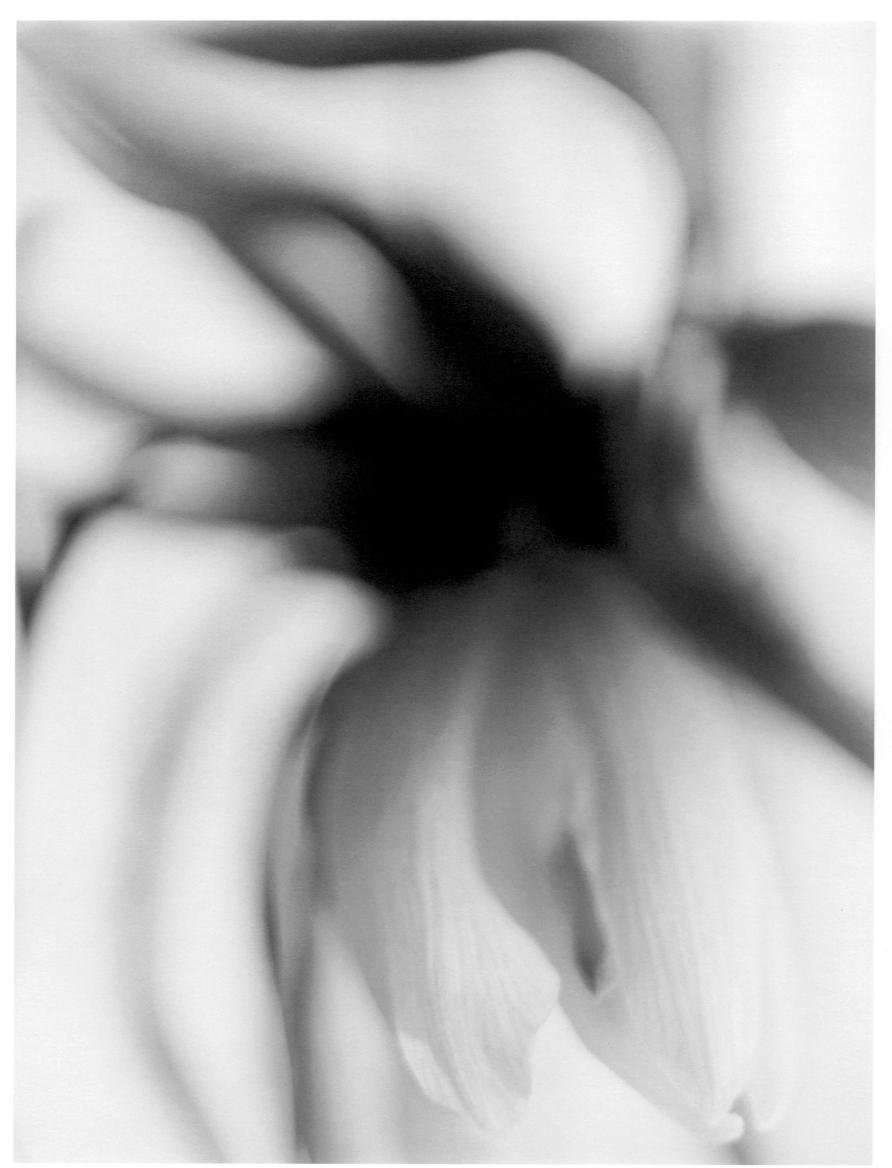

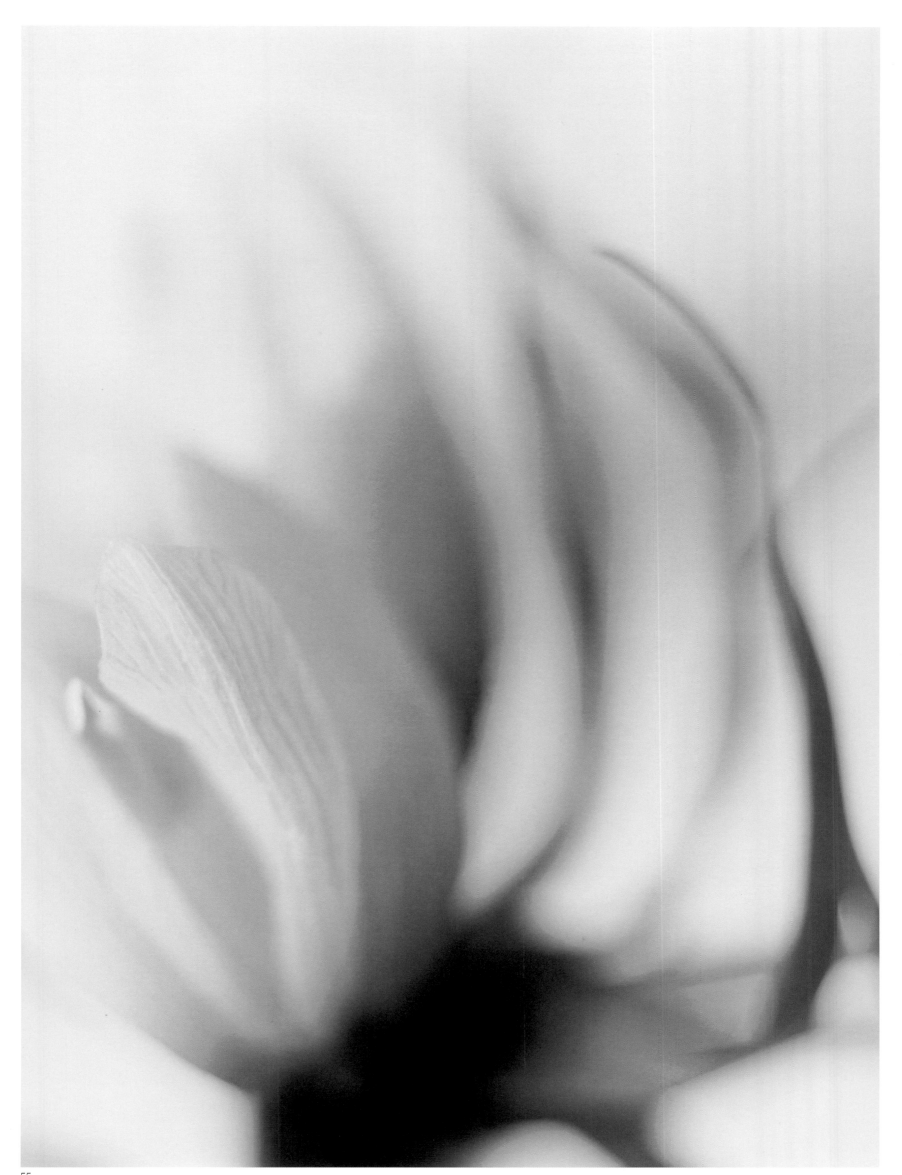

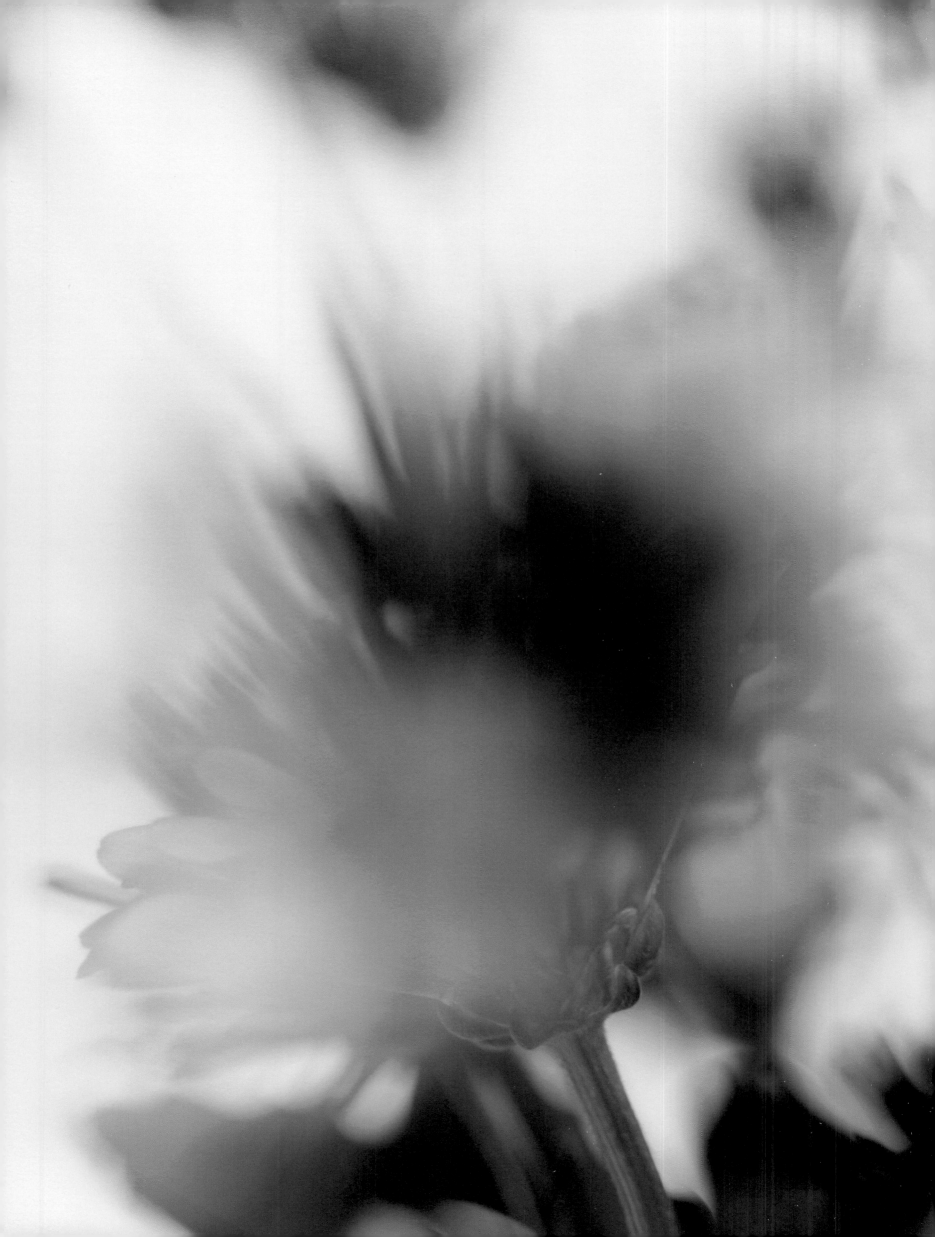

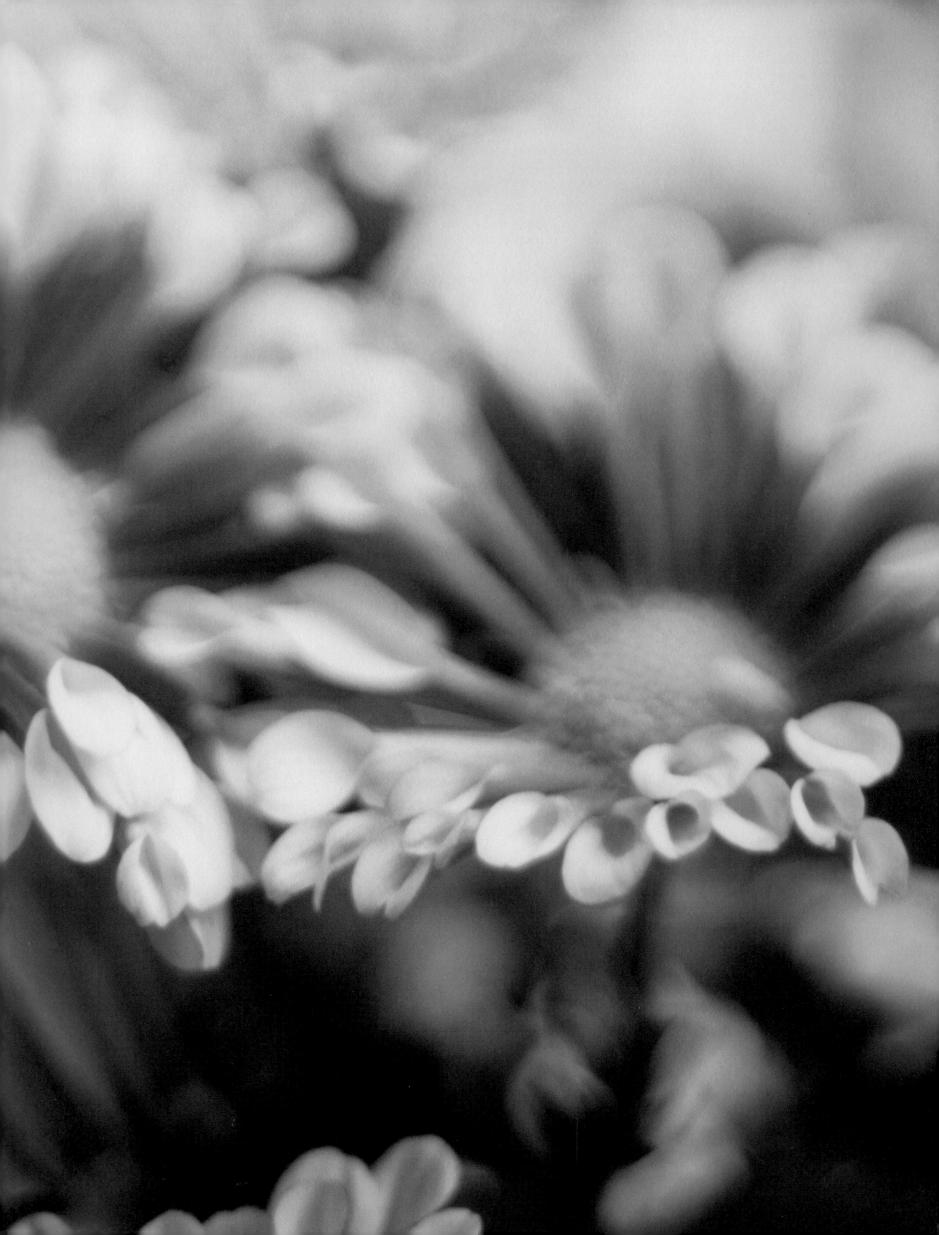

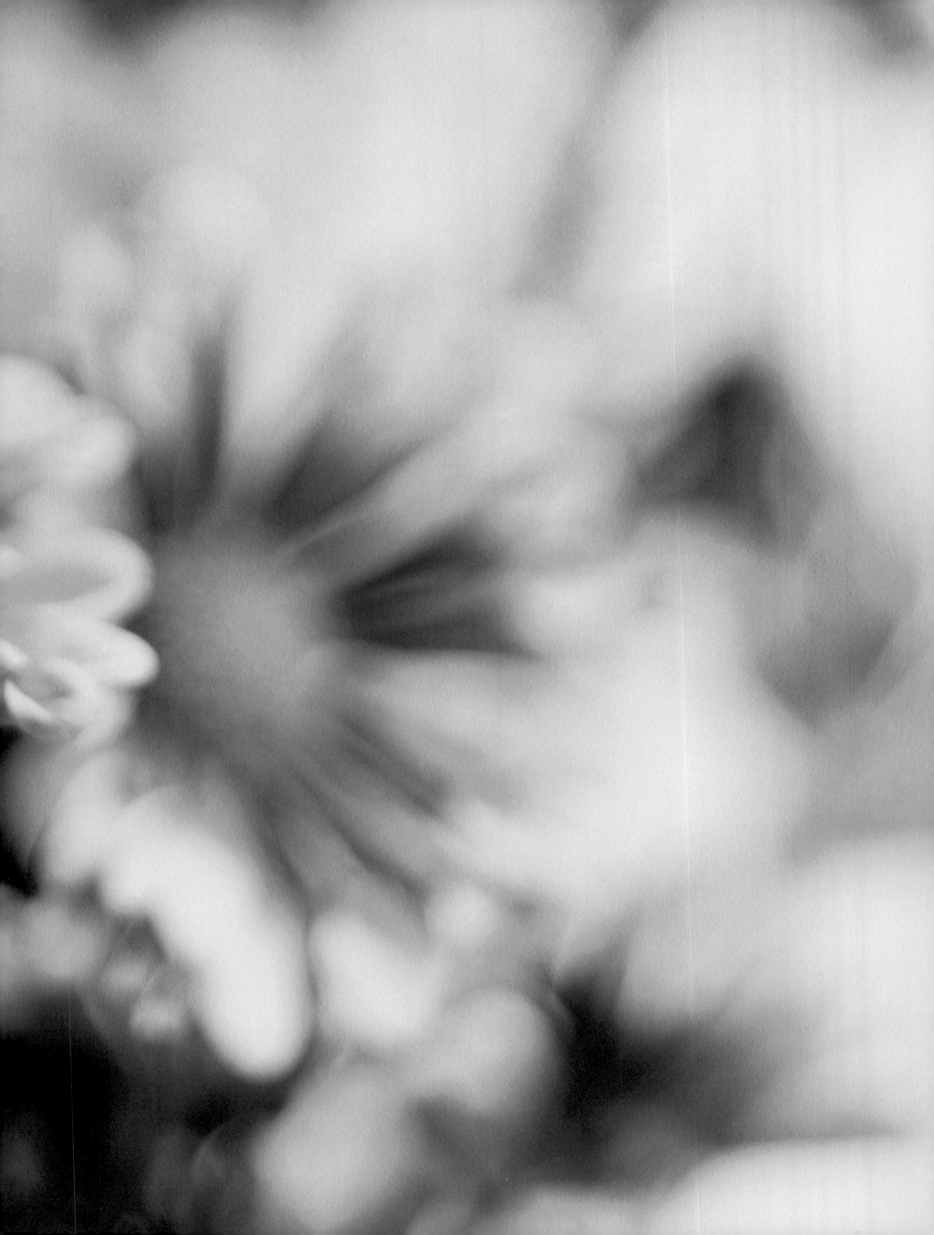

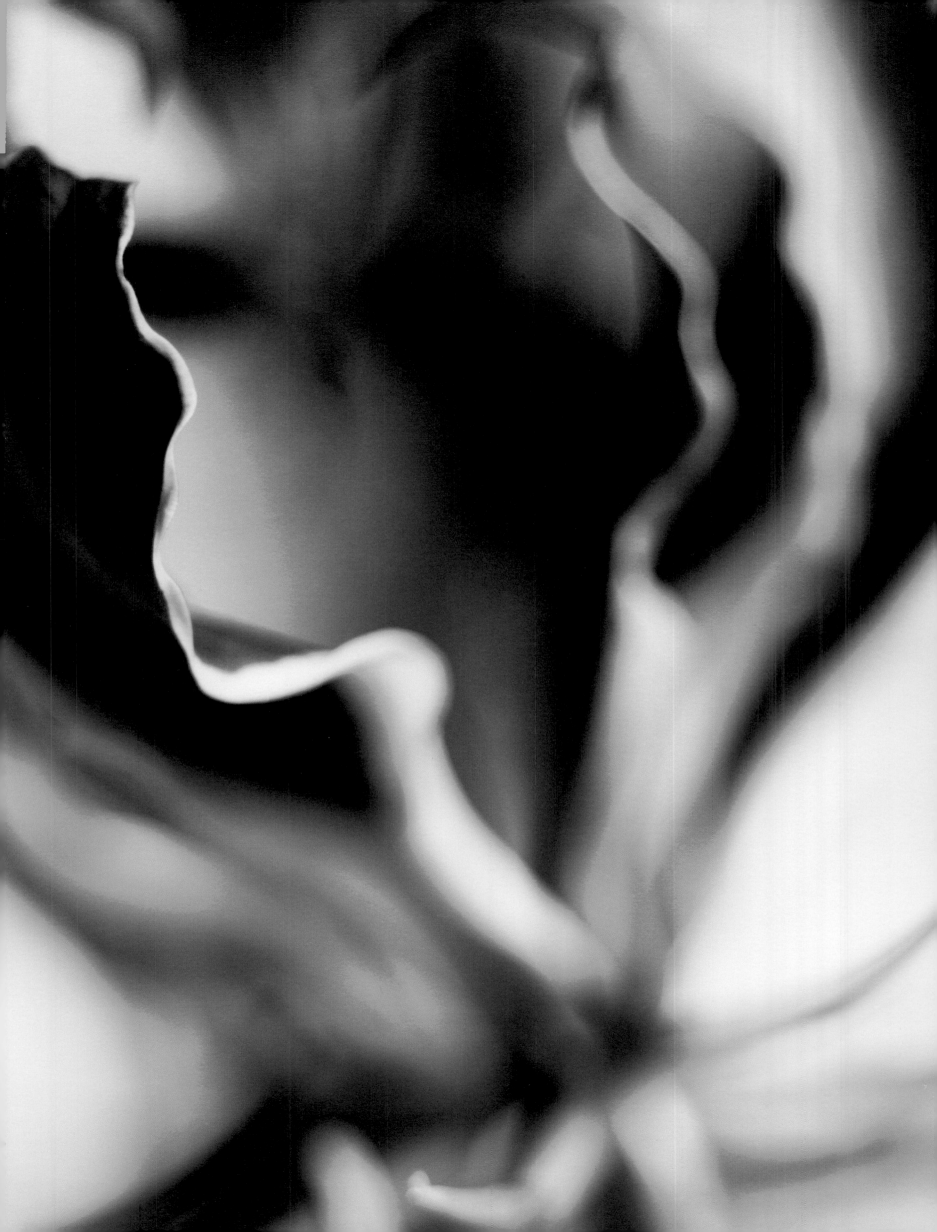

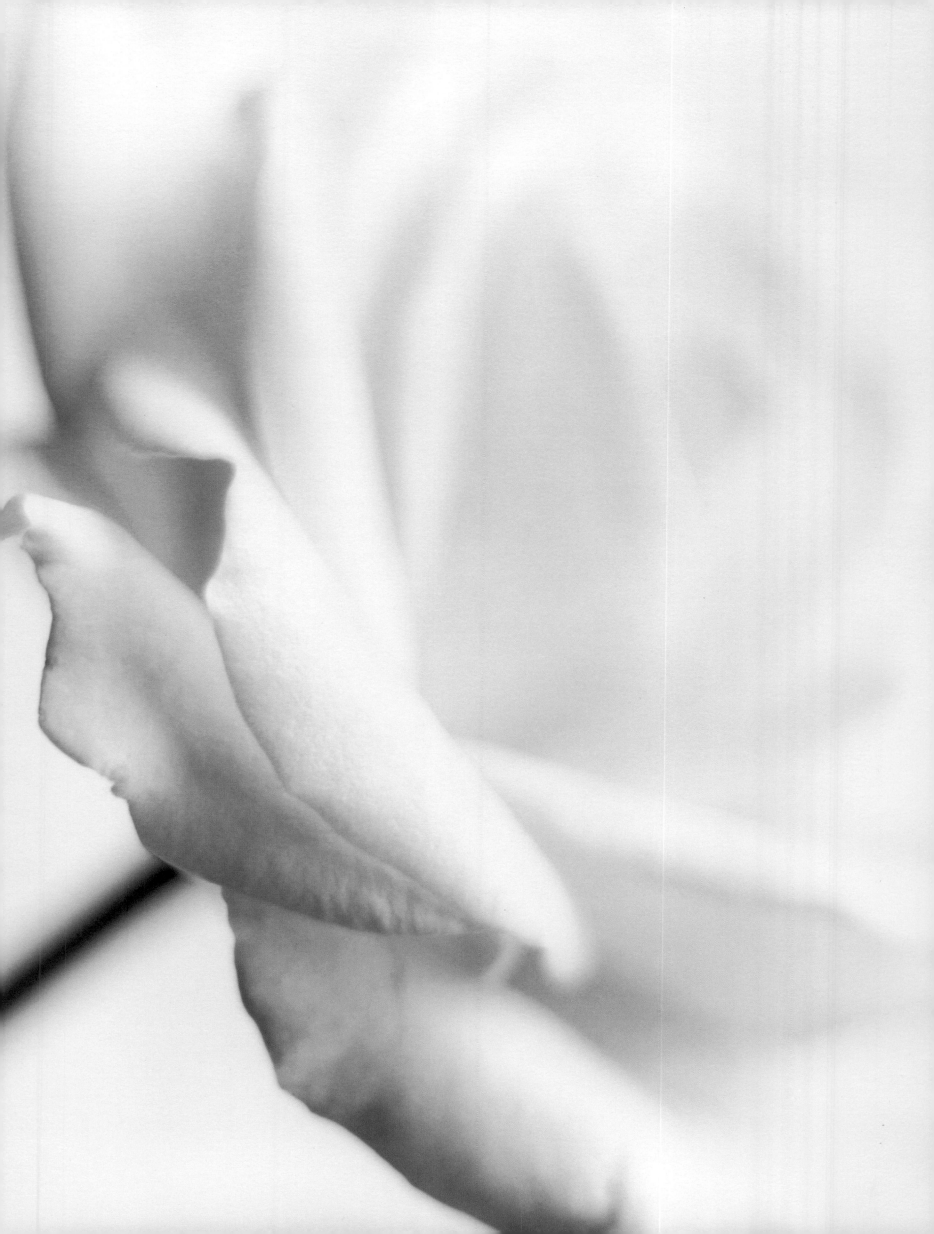

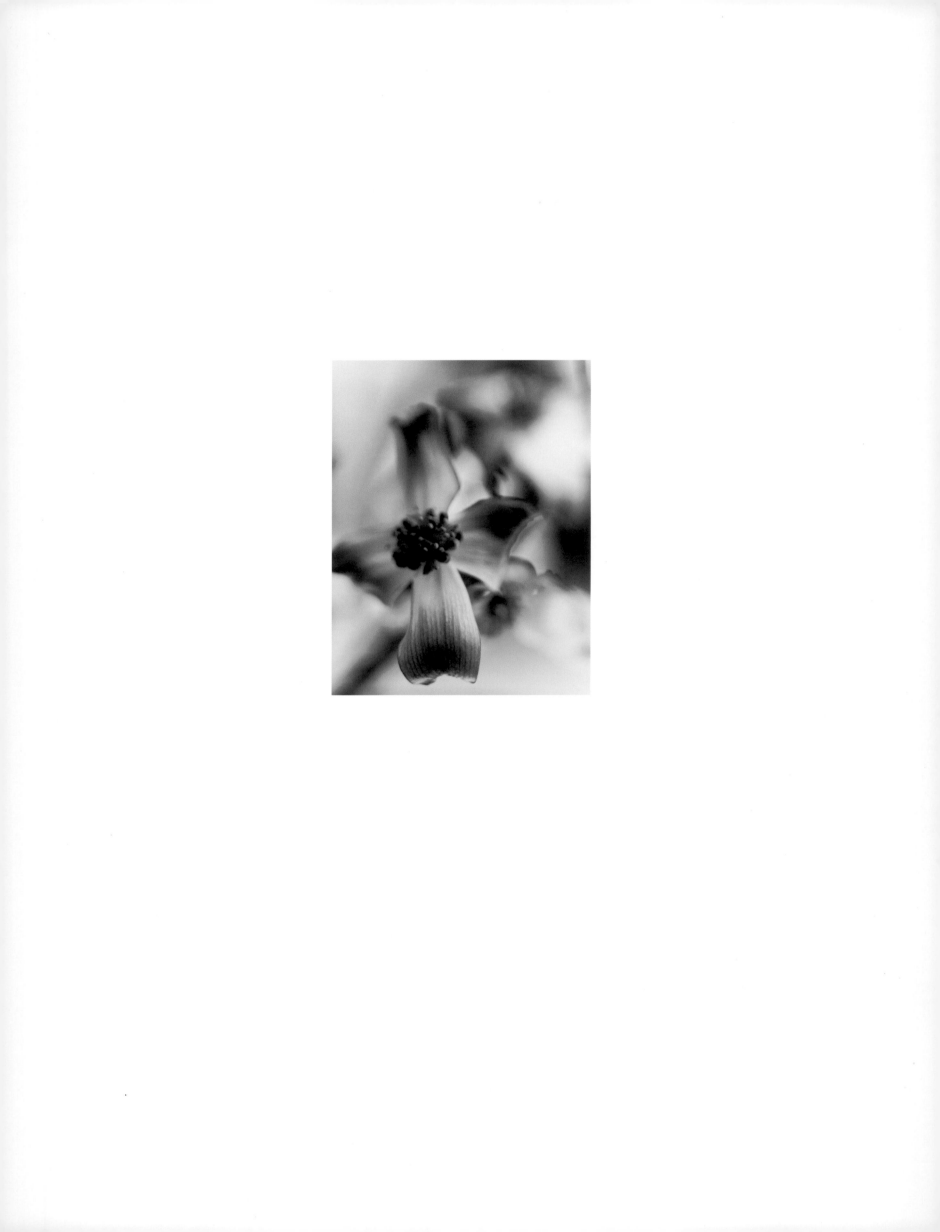

List of Plates

Of Secret Passages

Jerry Aline Flieger

... The true religious force in the world is the world itself ... an aesthetic tough, diverse, untamed, incredible to prudes, the mint of dirt, green barbarism turning paradigm.
Wallace Stevens

"Becoming" as "Line of Flight"

Gilles Deleuze—arguably the most influential postmodern philosopher—describes the artist's work as a provocative and unsettling "line of flight" away from ordinary experience and perception. In this postmodern aesthetic, the line of flight is likened to the zigzagging series of passes that an insect makes to the flower, effecting the amorous linkage of orchid and wasp, bee and blossom, in an act of cross-pollination.

Sandi Fellman's work performs such a line of flight, describing "becomings" or passages, without definite beginnings and endings, a play of shifting light that resists reduction to any single interpretation. In these disturbingly beautiful photos the flower "becomes" something else, harboring an almost animal or insectival presence. In turn, the work of art actively affects the viewers, who are "captured" by the image, thereby leaving their usual boundaries, becoming ... something else.

These animate objects are in between animal and vegetal life, in between movement and stillness, showing secrets openly, while "secreting" their sensual essence, both inviting and sinister. In other words, this intimate participatory art of "becoming" is a process of identification. As Deleuze writes, the animals, flowers, or stones "[are] not subjects, objects or forms that we know from the outside."[1] Fellman's open secrets are permeable objects that nonetheless resist "knowledge" from the outside, even as they invite the viewer to penetrate and participate in their secret life.

This work is richly erotic and sensual, hinting at the secret life of the organic, without being "feminine" or even categorizable as strictly "floral." We are induced to view objects from startling perspectives, and sometimes experience disorientation ("What is it?"). Again, Fellman's luxuriant images seem highly sexualized without specific references or self-conscious sexual metaphor. This is because the work itself is in motion, fluid, enacting a process of exchange and interpenetration rather than recording a mimetic event.

One might say that Fellman's work presents a transgendered erotic interaction. Whereas traditional gendered sexuality is a binary organization with defined territories—"either"/"or," "his"/"hers," "capture"/"surrender"—the postmodern aesthetic is based on a mingling of differences in a "string of multiplicities," "either ... or ... or," where innocence meets complicity. Commenting on Proust's floral imagery, Deleuze writes: "[...] the innocence of flowers brings us yet another message and another code: everyone is bisexual, everyone has two sexes."[2] Male/female becomes male ... female, "strung out" in the flight from a stable self in the experience of art as an intense rite of passage.

Curve: The Lure of Nonlinear Form

Open secrets puts into play an aesthetics of migration, of passes between shoot and petal and stem. In Deleuze's material rendering, this intertwining becomes textile, where "a fiber strung across borderlines constitutes a line of flight,"[3] expressed in images of webbing or entangled vine.

Indeed, in Fellman's exposition of floral mystery, we have an example of what postmodernists have called "rhizomatic" organization, like a network of connecting veins or roots. In this meshwork, it is a question not only

of stringing but also of hanging together, producing consistency, a texture that is viscous. Fellman's photos are at once organic and inorganic, disjunctive and synthetic: they are a productive encounter of metallic/chemical reactions (photography itself) and a botanical play of fleshy tissue, linking process and image.

In photography, the mechanics of becoming are finally reducible to material forces, matter and energy, the ebb and flow of intensity, quite literally at the molecular level. This play of differences, and the use of relative intensities, is exploited in Fellman's artistry, which is consistent with a postmodern aesthetic of movement and inflection, a function of material differences and intensities that Deleuze has called "capacities to affect and be affected." Fellman's photos embody this capacity to affect and be affected, in an exchange between viewer and viewed. This leads to a confusion or mingling of perspectives, which, as in much postmodern writing and art, no longer sees passages as a means to an end.

Rather than describing a trajectory, Fellman's voyeuristic encounter with the intimate life of flowers leads to a secret garden, a labyrinth, scene of reciprocal capture and mutual "becoming," where neither term conquers or even lures the other. Indeed it is difficult to contemplate Fellman's florid images without experiencing an almost insect presence, voraciously sensual, part flower, part predator. Fellman's floral zones suggest overlap and linkage—of one image with the other, of one organism with another, and of viewer with viewed—"either" flower "or" insect "or" bird "or" web ... all at once. Moreover, an immemorial quality infuses this photography—a deep timelessness or amnesia both lulls and unsettles the viewer, who, in turn, consumes and is consumed by the moving image. This art functions to form a network of aesthetic response, where one loses one's "self" in the process of discovering another.

Fellman's living stasis, her fluid floral events, correspond to an aesthetic which does not imitate the real but performs it, as in a dance, thanks to a play of sustained ambiguities—unresolved contradictions, open secrets. Or as Deleuze puts it, the work of art is not concerned with reproducing likenesses, but with producing comminglings fraught with intensity, where "nothing is representative, it is all life and lived experience."[4] What do these images "mean" or represent? That remains an open secret. a clue in full view.

Theme and Variation: Rhizome as Series

"Rediscover Mozart and that the theme was a variation from the start."[5]

Another way to characterize the elusive appeal of Fellman's open secrets is to "listen" to the visual whispering as theme and variation. Fellman's work deploys difference (the various floral subjects) and repetition (a series of thematic essays) in an art of immanence and becoming, as in the musical theme and variation. Costumed by the overlay of exhibition and disguise, these flowers are cross-dressers cloaking masculine predation in layers of feminine seduction. (When one is confronted with a blatantly "phallic" flower, one feels its nudity as an aggression ...)

It might be tempting to receive this work as a simple festival of the senses, emphasizing ornament and lush beauty. But rather than providing indulgence and comfort, Fellman's photos enact an intense dance, as the flowers ask to be touched, while "penetrating" us in turn, luring the eye which "penetrates" them and which they actually come to resemble. Her open secrets invite us to a realm where, as Deleuze reminds us, "one's entire soul flows into this emotion that makes the mind aware of the terribly disturbing sound of matter."[6]

The force of open secrets is that they resist opening, but still lead us to dangerous liaisons with matter, in its darkest passages.

[1] Deleuze, Gilles and Guattari, Fëlix. *A Thousand Plateaus: Capitalism and Schizophrenia*, Minneapolis, 1987 (1980), p. 279.

[2] Deleuze, Gilles and Guattari, Fëlix. *Anti-Oedipus: Capitalism and Schizophrenia*, Minneapolis, 1983 (1972), p. 69.

[3] Cf. Deleuze (see note 1), p. 252.

[4] Cf. Deleuze (see note 2), p. 19.

[5] Cf. Deleuze (see note 1), p. 309.

[6] Cf. Deleuze (see note 2), p. 19.

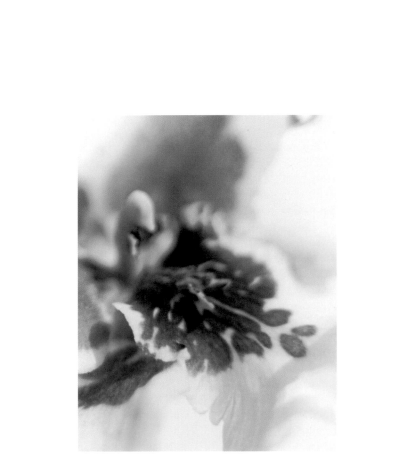

Acknowledgements

I am delighted to have this opportunity to thank some of the extraordinary people in my life who have helped me make these photographs and this book.

First, I want to thank Cavalliere Ketchum, my photography professor, for bringing photography into my life over 26 years ago. I am grateful to my dear friends Russ Hardin and Eelco Wolf for their longstanding friendship and tremendous support of my work. Thanks to Jodi Hardin and Judy Casey for sharing their inspiring gardens with me. And thanks to Hillary Offenberg and Joe Gulotta at Fischer & Page for understanding my needs and desires on those early mornings in the flower market. Doug Keljikian deserves great praise for his patient and sensitive assistance. Thank you to Kelton Labs for handling my film with such care. And most important, my deepest gratitude to Steve Rifkin for his masterful and exquisite printing of my images and for his constant faith and good humor. Edwynn Houk and the staff of the Edwynn Houk Gallery have been most gracious and supportive in representing these pictures. Susan Arthur Whitson, Shelley Rice, Käla Mandrake and Mark Magowan must be thanked for each of their special contributions to the evolution of this book. Robert Züblin, Mirjam Ghisleni-Stemmle, and Thomas N. Stemmle have been a pleasure and inspiration to work with. And I am honored to have Diane Ackerman's and Jerry Aline Flieger's words and Coleman Bark's beautiful translation of a poem by Jelaluddin Rumi to grace my photographs. Lastly, I want to thank my family, Charlie and Zander Nafman, for making my life a daily celebration. "In all of your light I learn how to love."

Editorial direction by Mirjam Ghisleni-Stemmle, Lisa Briner
Translation of the Rumi poem by Coleman Bark
Layout and Typography by Guido Widmer and Giorgio Chiappa
Typesetting and Lithography by Alpha Druckereiservice GmbH, Radolfzell, Germany
Printed by Druckerei Konstanz GmbH, Konstanz, Germany
Bound by Buchbinderei Burkhardt AG, Mönchaltorf/Zurich, Switzerland

ISBN 3-908163-01-3